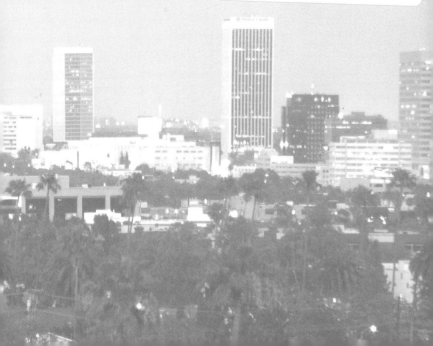

LOS ANGELES

architecture & design

Edited and written by Karin Mahle
Concept by Martin Nicholas Kunz

teNeues

content

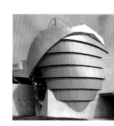

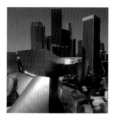

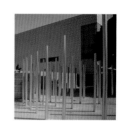

to see . culture & education

to see . public

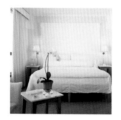

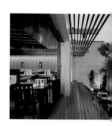

to stay . hotels

to go . eating, drinking, clubbing

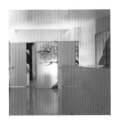

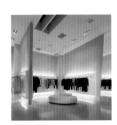

to go . wellness, beauty & sport

to shop . mall, retail, showrooms

introduction

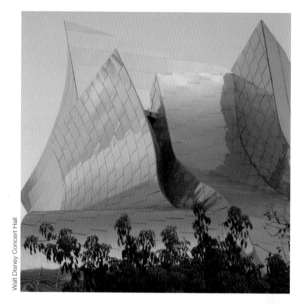

Walt Disney Concert Hall

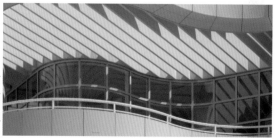

Getty Center (Detail)

Architecturally, Los Angeles is one of the most innovative and diverse cities in the world. The warm climate combined with the creativity of the movie industry has pushed every style a little further than anywhere else.

Besides the new exciting projects, the Getty Center, the Walt Disney Concert Hall and the new Cathedral, there is a lot to see. A new appreciation for mid-century modernism has inspired the re-use of existing structures, like the Avalon Hotel. Businesses are using architecture as a branding tool in daring new concepts for small projects, like the l.a. Eyeworks store. This is a guide to the newest architecture, on very different scales.

Was die Architektur anbelangt, gehört Los Angeles zu den innovativsten und vielfältigsten Städten weltweit. Das warme Klima in Kombination mit der Kreativität der Filmindustrie hat dazu geführt, dass sich hier jede Stilrichtung ein Stück weiter nach vorne entwickeln konnte als anderswo auf der Welt.

Neben den neuen, aufregenden Projekten, wie z. B. dem Getty Center, der Walt Disney Concert Hall und der neuen Kathedrale, gibt es noch sehr viel mehr zu sehen. Eine neue Aufgeschlossenheit für den Modernismus der Jahrhundertmitte diente als Inspiration für die Wiederverwendung bestehender Strukturen, wie beispielsweise des Avalon Hotels. Unternehmen benutzen die Architektur als Markenzeichen bei gewagten neuen Konzepten für kleine Projekte, wie z. B. den Laden l.a. Eyeworks. Ein Städteguide über die neueste Architektur – in sehr unterschiedlichen Größenordnungen.

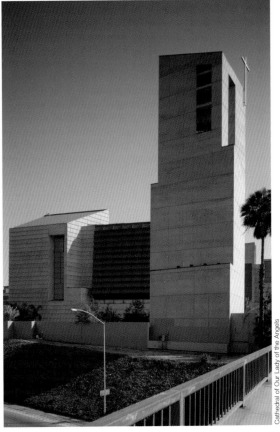

Cathedral of Our Lady of the Angels

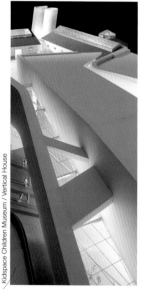

Kidspace Children Museum / Vertical House

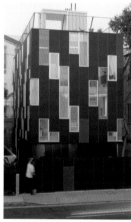

Avalon Hotel

Par l'architecture, Los Angeles est l'une des cités les plus innovantes et variées de la planète. Son climat chaud et la créativité de son industrie cinématographique ont toujours poussé les styles un peu plus loin qu'ailleurs.

Outre d'intéressants nouveaux projets comme le Getty Center, le Walt Disney Concert Hall et la nouvelle cathédrale, il y a beaucoup d'autres choses à voir. C'est une réappréciation du modernisme des années 50 qui a inspiré la réutilisation des structures en place, dont l'hôtel Avalon. Les entreprises se servent de l'architecture comme d'un outil à forger leur griffe, et sous-tendent de concepts audacieux même les petits projets, tels le magasin l.a. Eyeworks. Voici donc un guide de la plus récente architecture, à des échelles très différentes.

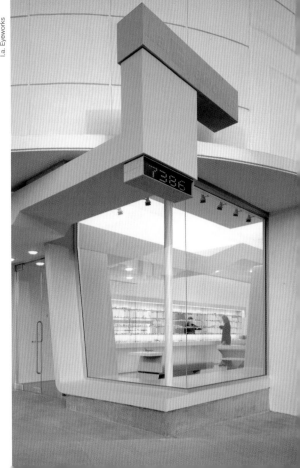

I.a. Eyeworks

Arquitecturalmente, Los Angeles es una de las ciudades mas innovadoras y diversas en el mundo. El clima cálido combinado con la creatividad de la industria cinematográfica ha conmovido todo tipo de estilo de diseño a ir más allá de la meta.

Además de los emocionantes proyectos como el Getty Center, Walt Disney Concert Hall y la nueva Catedral, hay mucho mas por ver. La nueva apreciación por la modernidad de mediados de siglo ha inspirado el re-uso de estructuras existentes, como la del Hotel Avalon. Lugares de negocios ahora usan arquitectura de forma audaz como herramienta que ayuda a renombrar nuevos conceptos para pequeños proyectos, así como la tienda l.a. Eyeworks. Esta es una guía hacia la arquitectura más nueva sobre escalas muy diferentes.

to see . living
office
culture & education
public

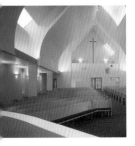 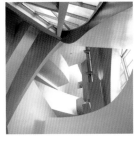

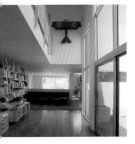 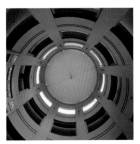 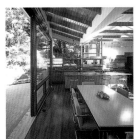

 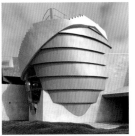 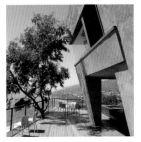

Seatrain Residence

David Mocarski, Jennifer Siegal

2003
1920 North Main Street
Downtown

www.designmobile.com

The site is in an industrial area of downtown. The materials used were either found on the site or inspired by it. Storage containers and steel from the site were recycled together with new industrial materials to create a surprisingly poetic and contemplative residence.

Das Grundstück liegt in einem Industriegebiet nahe der Innenstadt. Baumaterialien, die auf dem Bauplatz herumlagen, wurden wieder verwendet und durch ähnliche Baumaterialien ergänzt. Vorgefundene Container und Stahlträger fügen sich mit den neuen Elementen zu einem überraschend poetischen und meditativen Ambiente zusammen.

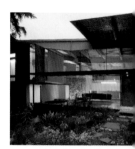

Ce site est une zone industrielle du centre-ville. Soit les matériaux utilisés ont été trouvés ici, soit l'endroit a servi d'inspiration à leur emploi. Les conteneurs de stockage et l'acier présents sur site ont été recyclés avec de nouveaux matériaux industriels pour créer une résidence dont la poésie et le tempérament contemplatif surprendront.

El emplazamiento esta situado en un área industrial del centro de la ciudad. Los materiales usados fueron encontrados en el mismo y al igual nacieron por medio de la inspiración que esta atrajo. Contenedores de embarque y acoplados de grava fueron reciclados con nuevo material industrial para crear una residencia poética y contempladora.

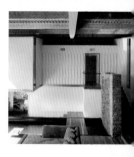

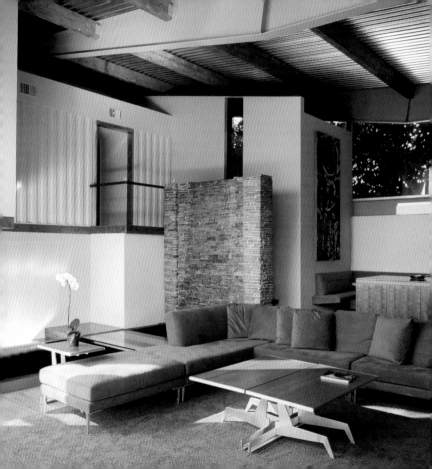

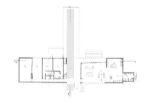

Jai House

Lorcan O'Herlihy Architects
Paul Franceschi Engineering (SE)

2003
Silverlake

www.loharchitects.com

Following the tradition of the Case Study Program, the Jai House encourages the interaction between inside and outside. A pool that runs through the middle and a spectacular master suite on top of an outdoor staircase completes this reinterpretation of a Southern Californian classic.

Gemäß der Traditionen der Case Study Houses verwischt das Jai-Haus die Grenzen zwischen Innen- und Außenraum. Ein Schwimmbecken zieht sich durch die Mitte des Hauses, und ein spektakulärer Schlafzimmer-Kubus über einem offenen Treppenhaus rundet die Neuinterpretation eines südkalifornischen Klassikers ab.

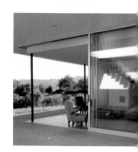

Fidèle à la tradition du programme d'études de cas, la Jai House encourage l'interaction entre l'intérieur et l'extérieur. Une piscine qui traverse le milieu et une suite spectaculaire surplombant une cage d'escaliers complètent cette réinterprétation d'un classique en Californie du Sud.

Siguiendo la tradición del Case Study Program, la casa Jai promueve la interacción entre el interior y el exterior. Una piscina atraviesa la mitad y un espectacular master suite en la parte superior de una escalera situada en el exterior completa esta reinterpretación de un arquetipo clásico del Sur de California.

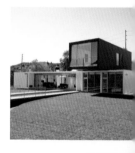

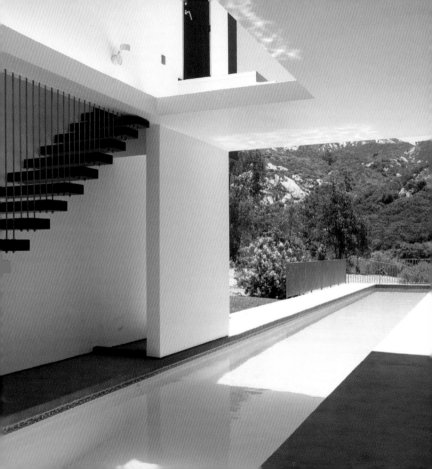

House on Highland Avenue

PXS
Efficient Consulting Engineers (SE)

2002
950 South Highland Avenue
West Hollywood

To block out the noise of busy Olympic Boulevard, the house sits right on the edge of the site like a wall. Only two skinny windows penetrate this wall. From the inside, they look like flat screen monitors built into the bookshelves.

Um die Geräuschkulisse des vielbefahrenen Olympic Boulevard auszublenden, ist das Haus wie eine Lärmschutzwand direkt auf die Grundstücksgrenze gesetzt. Nur zwei schmale Fenster durchbrechen diese Mauer. Von innen sehen sie aus wie Flachbildschirme, die in eine Bücherwand eingebaut sind.

Pour faire barrage au bruit de l'Olympic Boulevard, la maison repose exactement sur le bord du site, telle un mur. Deux fenêtres très minces traversent ce mur. De l'intérieur, elles ressemblent à écrans plats intégrés dans les bibliothèques.

Para obstruir el ruido del ocupado Bulevar Olympic, la casa esta situada justo ala orilla del emplazamiento como si fuese una pared. Solo dos ventanas angostas la penetran y por el interior parecen monitores planos construidos en el librero que forma esta pared.

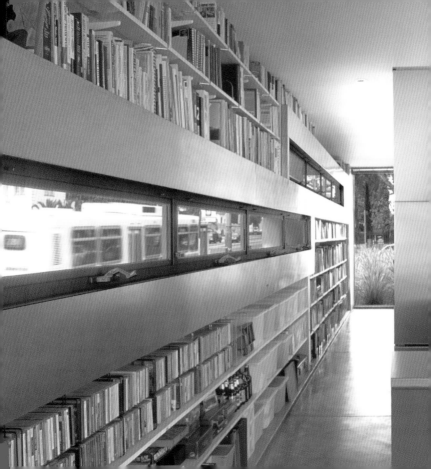

Rustic Canyon House

Griffin Enright Architects
Gordon Polon Engineering (SE)

2001
Beverly Hills

www.griffinenrightarchitects.com

A steep hillside with 200 year old sycamore trees inspired the architect and the owners to turn the views towards the trees and the hill and to create a large, loft-like space that opens up as much to the outside patio as possible.

Ein steiler Hang mit 200 Jahren alten Platanen inspirierte die Architekten und die Besitzer, die Aussicht auf die Bäume und den Hügel zu orientieren und einen großen, loftartigen Raum zu schaffen, der sich so weit wie möglich zu einem außenliegenden Patio öffnet.

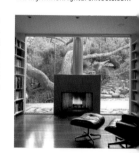

Un flanc de colline escarpé et des sycomores deux fois centenaires ont inspiré à l'architecte et aux propriétaires l'idée de braquer la vue vers les arbres et la colline, pour créer ainsi un vaste espace, similaire à un loft, qui s'ouvre autant que faire se peut sur le patio extérieur.

Una inclinación de una montaña con árboles de sicomoro de 200 años fue parte de la inspiración del arquitecto y propietario en este proyecto para enfocar la vista hacia los árboles y la montaña y de esta manera crear un espacio amplio que se abriera hacia el patio exterior.

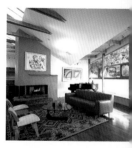

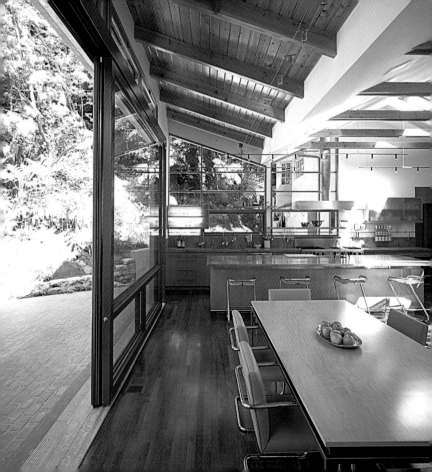

Rochman House

Callas Shortridge Architects
Joseph Perazzelli (SE)

2000
Pacific Palisades

www.callas-shortridge.com

To maximize the spectacular view of the ocean below, the entry level juts out across the lower level, allowing a full view of the Malibu coastline. The tilting glass panels give the viewer the feeling of being suspended on a cliff above the sea below.

Um den fantastischen Blick über den darunter liegenden Ozean voll auszunutzen, ragt das Eingangsgeschoss über das untere Stockwerk hinaus und gewährt einen Panoramablick über die Küste von Malibu. Die schräg gestellten Glasscheiben geben dem Betrachter das Gefühl, am Rande einer Klippe über dem Meer zu stehen.

Pour amplifier le caractère spectaculaire de la vue sur l'océan en contrebas, le rez-de-chaussée part en saillie et couvre ainsi tout le niveau inférieur pour offrir ainsi une vue intégrale sur le littoral de Malibu. Les panneaux de verre basculant donnent à l'observateur l'impression d'être suspendu à une falaise au-dessus de la mer.

La entrada principal de esta casa marca el término del nivel en la que esta se encuentra; llegando al último nivel permitiendo vista completa a la costa de Malibu, de manera de expandir la vista tan espectacular hacia el océano. Son los paneles de vidrio inclinados los que producen el efecto de estar suspendidos de la montaña sobre el mar.

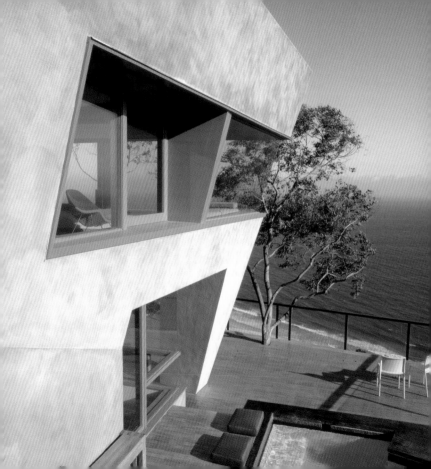

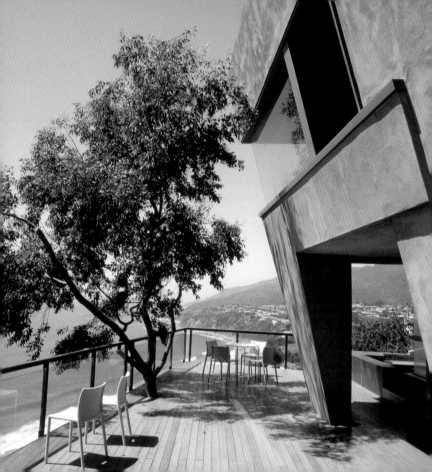

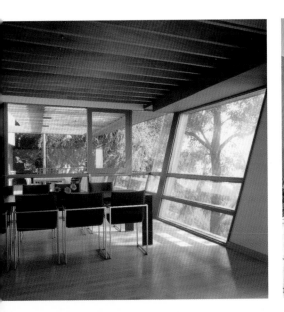

Colorado Court

Pugh + Scarpa Architects

2001
502 Colorado Avenue / Fifth St
Santa Monica

www.pugh-scarpa.com

Most of the exterior walls of this apartment building are clad in solar panels. In a city that usually restricts solar panels to the back of houses, this 100% energy self sufficient building makes an ecological and political statement.

Der größte Teil der Außenfläche dieses Mehrfamilienwohnhauses ist mit Solarpaneelen versehen. In einer Stadt, die normalerweise Solarpaneele an die Rückseite der Häuser verbannt, macht dieses Gebäude, das seinen Energiebedarf zu 100 Prozent selbst deckt, eine ökologische und politische Aussage.

La plupart des murs extérieurs de cet immeuble résidentiel sont habillés de panneaux solaires. Dans une ville qui normalement restreint l'emploi des panneaux solaires à l'arrière des maisons, cet immeuble 100 % en autosuffisance énergétique est à lui seul une véritable déclaration de politique environnementale.

En esta ciudad donde usualmente esta restringido integrar células fotovoltaicas en la parte posterior de las casas, este proyecto marca la pauta. Donde la mayoría de las paredes exteriores de este complejo de viviendas las integran, produciendo su energía al 100% y planteando un tema ecológico y político.

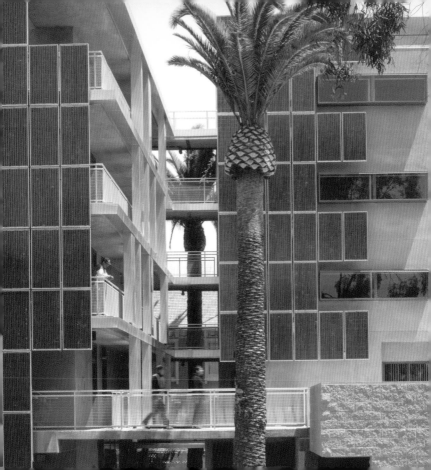

Abbot Kinney Lofts

Mack Architect
Parker Resnick Engineers (SE)

2001
1318, 1320, 1324 Abbot Kinney
Boulevard
Venice

www.markmack.com

The artist community of Venice now has a complex that was specifically designed for artists to live and to work there. Most of the units are on two levels, making studio visits during open house events possible while protecting the privacy of the tenants.

Die Künstler-Kolonie von Venice hat nun einen Gebäudekomplex, der speziell für Künstler entworfen wurde, die dort wohnen und arbeiten können. Der Großteil der Einheiten ist zweigeschossig angelegt, so dass bei Veranstaltungen Werkstattbesuche möglich sind, ohne die Privatsphäre der Künstler zu verletzen.

La communauté artistique qui s'est établie à Venice habite maintenant un complexe spécifiquement conçu pour les artistes vivant et travaillant ici. La plupart des unités s'étendent sur deux niveaux, rendant les visites de studio possibles lors des journées portes ouvertes, tout en protégeant la vie privée des résidents.

La comunidad de vivienda para artistas situada en la ciudad de Venice ahora posee un complejo que fue específicamente designado para vivir y trabajar. La mayoría de las unidades son de dos niveles, haciendo las visitas de talleres posibles durante eventos y protegiendo la privacidad de los habitantes.

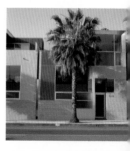

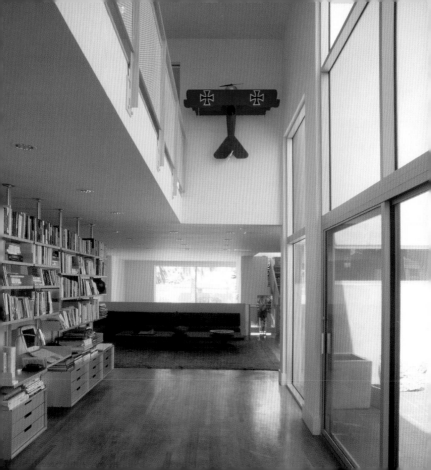

Glencoe Residence

Marmol Radziner & Associates

2002
Venice

www.marmolradziner.com

This beautifully detailed house has many unusual spatial configurations. An outside area is designed as a living room with an exterior fireplace and a room above. The pool right next to the fireplace makes good use of a small yard as a succession of exterior rooms.

Dieses detailreiche Haus bietet viele ungewöhnliche räumliche Konfigurationen. Ein Außenraum wird durch einen Kamin und ein auskragendes Obergeschoss zu einem Wohnraum. Das Schwimmbecken direkt neben dem Kamin profitiert von einem kleinen Hof, der eine Abfolge von Außenräumen einleitet.

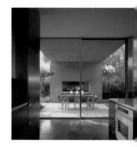

Cette maison aux détails joliment soignés présente plusieurs configurations spatiales peu banales. Un espace extérieur a été conçu en salle de séjour avec cheminée en plein air avec une pièce audessus. La piscine, jouxtant la cheminée, profite d'une petite cour qui enchaîne sur les pièces du dehors.

Esta hermosa casa detallada tiene muchas configuraciones de espacios inusuales. Así como una de las áreas exteriores que fue diseñada como sala con una chimenea y un cuarto arriba. La piscina a lado de la chimenea se convierte en el sucesor hacia los cuartos exteriores.

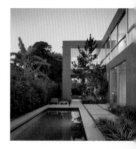

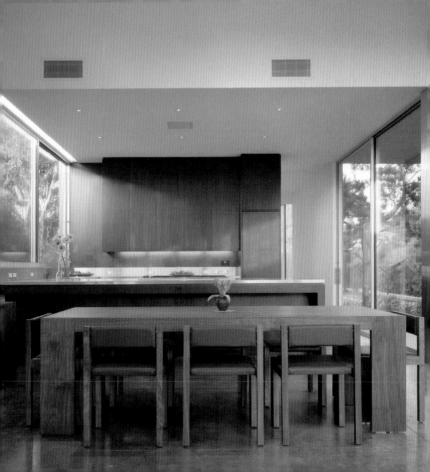

Vertical House

Lorcan O'Herlihy Architects
Paul Franceschi Engineering (SE)

2003
Venice

www.loharchitects.com

The Vertical House is the architect's own residence. The urban infill situation made it necessary to design the house as a simple, compact box and to concentrate architectural expression on the skin of the building, the envelope of the box.

Das Vertical House gehört dem Architekten selbst. Die Situation einer städtischen Baulücke zwang ihn, das Haus als eine einfache, kompakte Kiste zu entwerfen und sich in seinem architektonischen Ausdruck auf die Gebäudehaut, die Fassade, zu konzentrieren.

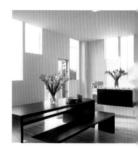

La Maison Verticale est la résidence personnelle de l'architecte. Sa situation urbaine, sur terrain intercalaire, a rendu nécessaire de concevoir la maison sous la forme d'une boîte simple et compacte, et de concentrer l'expression architecturale sur l'épiderme de l'édifice, l'enveloppe de la boîte.

La casa vertical pertenece al mismo arquitecto. El diseño de esta casa fue basado principalmente en la existente situación urbana; tan simple como una caja compacta y concentrando la expresión arquitectónica en la fachada, la envoltura de la caja.

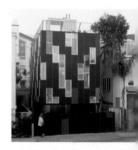

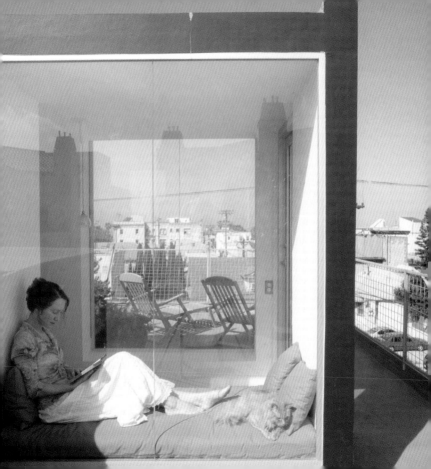

Walden Wilson Studio

Johnston Marklee
William Koh and Associates (SE)

2002
4232 Mentone Avenue
Culver City

www.johnstonmarklee.com

A simple studio on top of a garage becomes a sculptural piece through the vertical addition of three boxes: garage, studio and skylight shaft. The minimal, dematerialized shapes and the stair give it an air of a UFO that has just landed.

Ein einfacher Atelierraum über einer Garage wird zu einer skulpturalen Komposition – durch das Übereinanderstapeln dreier Boxen: Garage, Atelier und Oberlichtschacht. Die minimalen, entmaterialisierten Formen und die Teppe lassen das Ganze wie ein UFO erscheinen, das gerade gelandet ist.

Un simple studio juché sur un garage devient une sculpture si on lui ajoute, verticalement, trois boîtes : un garage, un studio et un puits à lucarne faîtière. Les formes minimalistes et dématérialisées associées à l'escalier lui donnent un air d'OVNI qui vient d'atterrir.

Un simple taller arriba de un garaje se convierte en una pieza escultural a través de la adición vertical de tres cajas: garaje, taller, y un traga luz. Las formas minimalistas desmaterializadas de este y la escalera le dan un efecto de un OVNI acabado de aterrizar.

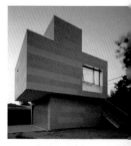

Jamie Residence

Escher GuneWardena
Andrew Nasser (SE)

2000
Pasadena

www.egarch.net

This cantilevered house clearly separates itself from a sloping hillside instead of working with the site. The front of the house is one single, open, public space to maximize the view of the city below.

Dieses auskragende Haus hebt sich deutlich von dem abfallenden Hang ab, statt sich an das Gelände anzupassen. Die Vorderfront des Gebäudes ist ein einziger offener öffentlicher Raum, um den Blick über die Stadt optimal zu nutzen.

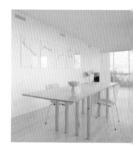

Cette maison en encorbellement se dissocie clairement du paysage à flanc de colline plutôt que d'épouser le site. Sa façade est un espace monolithique ouvert et public destiné à maximiser la vue sur la ville étalée à ses pieds.

Esta casa suspendida claramente se separa de la inclinación de la montaña, en vez de adaptarse al emplazamiento. El frente de la casa es un amplio espacio público que dirige la vista hacia la ciudad, la cual se encuentra bajo esta residencia.

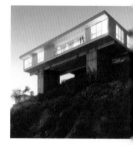

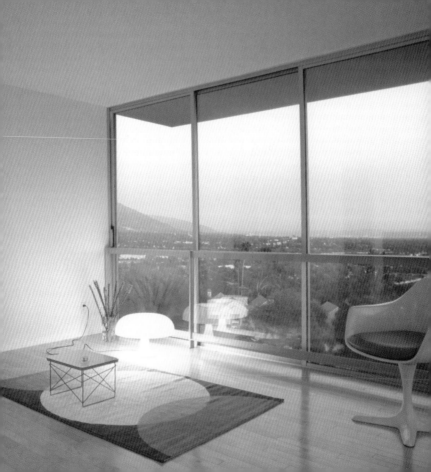

Valley Center House

Daly Genik Architects
Amando Paez (SE)

1999
San Fernando Valley

www.dalygenik.com

The client requested energy saving building techniques and a fire resistant exterior. Corrugated concrete board on the exterior and shading over outside areas make it a sparsely beautiful house, situated above a citrus and avocado ranch with ocean views.

Der Bauherr wollte ein Energie sparendes Haus mit feuerfester Außenhaut. Wellbetonplatten an der Fassade und der Sonnenschutz über dem Außenraum machen das Haus zu einer kargen, einfachen Schönheit, die oberhalb einer Zitrusfrucht- und Avocadoplantage mit Blick über das Meer liegt.

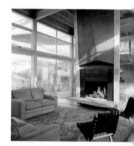

Le client exigeait des techniques de construction qui permettraient d'économiser de l'énergie, et un intérieur résistant au feu. Des plaques de béton ondulé sur l'extérieur et des jeux d'ombres dans les zones externes en font un domicile d'une beauté sobre, au-dessus d'une plantation d'agrumes et d'avocats et d'où la vue part sur l'océan.

El cliente requirió el uso de técnicas de ahorro de energía y un exterior de resistencia de fuego. Hormigón corrugado en el exterior y cubiertas de sombra, haciendo esta casa sobresaliente; situada arriba de un rancho de aguacate y cítricos con vista al océano.

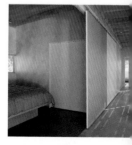

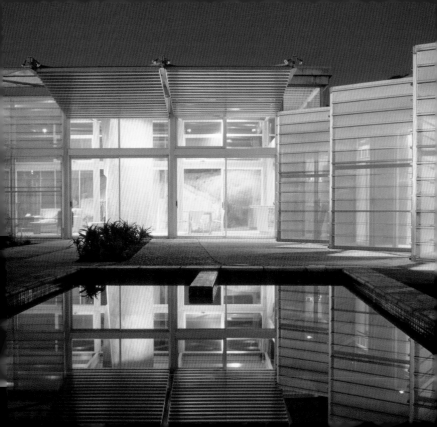

Caltrans 7 Headquarters

Morphosis
John A. Martin Associates (SE)

2004
312 North Spring Street
Downtown

www.morphosis.net

This office building commissioned by the State of California is the first of a new "Design Excellence Program". The perforated metal skin and the glass-mounted photovoltaic panels make this an innovative, exciting project, both architecturally and ecologically.

Dieses Bürogebäude, das vom Staat Kalifornien in Auftrag gegeben wurde, ist das erste eines neuen Bauprogramms, des „Design Excellence Program". Die perforierte Metallhaut und die auf Glas montierten Solarpaneele machen den Bau zu einen innovativen, spannenden Projekt – sowohl architektonisch als auch ökologisch.

Cet immeuble de bureau commandité par l'Etat de Californi est le premier d'un nouvea « Programme d'excellence d design ». La peau métallique per forée et les panneaux solaire montés sur verre en font un pro jet innovant et passionnant tan au plan architectural qu'écolo gique.

Este edificio de oficinas fue comisionado por el Estado de California, reconocido como el primero del nuevo "Design Excellence Program". La fachada perforada de metal y el vidrio en el que se integraron células fotovoltaicas hacen este proyecto innovador y emocionante de las dos formas arquitectónicamente y ecológicamente.

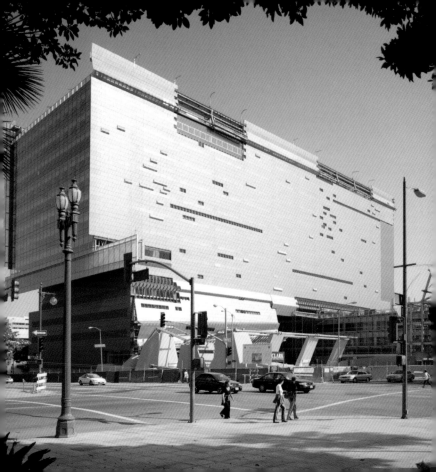

Napoli Management

Lorcan O'Herlihy Architects
Paul Franceschi Engineering (SE)

2003
8844 West Olympic Boulevard
Beverly Hills

www.loharchitects.com

Napoli Management is a talent agency for reporters. This relationship with film, photography and news media became a conceptual theme for the building, a remodel. A series of frames that start on the exterior are continued into the interior spaces.

Napoli Management ist eine Agentur für Reporter. Der Bezug zu Film, Photographie und Nachrichten-Medien wurde deshalb auch zum gestalterischen Thema des Entwurfes, eines Umbauprojekts. Eine Reihe übergroßer Fensterrahmen beginnt an der Außenfassade und setzt sich im Innenraum fort.

Napoli Management est une agence prospectrice de reporters talentueux. Ses relations avec le cinéma, la photographie et les médias du journal sont devenues un thème conceptuel pour le bâtiment, lui-même une réhabilitation. Une série de cadres partant vers l'extérieur trouvent leur continuation dans les espaces intérieurs.

La relación entre el fílmate, fotografía y el medio de noticias se convirtió en el concepto principal para la remodelación de Napoli Management, una agencia de talento para reportistas. Es la serie de estructura de este proyecto la cual remite el concepto; empezando desde el exterior y continuando hacia el interior de los espacios.

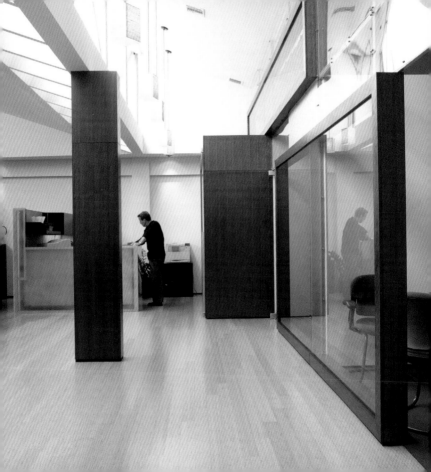

Beehive

Eric Owen Moss Architects
Kurily Szmanski Tchirkow, Inc. (SE)

1994
8520 National Boulevard
Culver City

www.ericowenmoss.com

Eric Moss has changed the face of Culver City, this is just one of many warehouse renovations that he has done. Typically, he uses a singular piece, as the beehive shaped entry building here, to give an area a name and recognition.

Eric Moss hat das Gesicht von Culver City grundlegend verändert. Dies ist nur eine von vielen seiner Lagerhausrenovierungen. In seiner typischen Art benutzt er ein einzelnes Objekt, hier ein Eingangsgebäude in Form eines Bienenstocks, um einer Gegend einen Namen und Wiedererkennungswert zu geben.

Eric Moss a changé la physionomie de Culver City, et cette réhabilitation d'entrepôt est l'une des nombreuses figurant à son actif. Il utilise une pièce singulière, comme ce bâtiment d'entrée configuré en nids d'abeilles, pour conférer au lieu un nom et la notoriété qui suivra.

Eric Moss ha cambiado la apariencia de Culver City, este es tan solo una de las tantas renovaciones de almacenes que el ha hecho. Usualmente su trabajo es reconocido con una solo pieza; aquí la entrada moldeada al edificio de Beehive, le da el nombre y reconocimiento al proyecto.

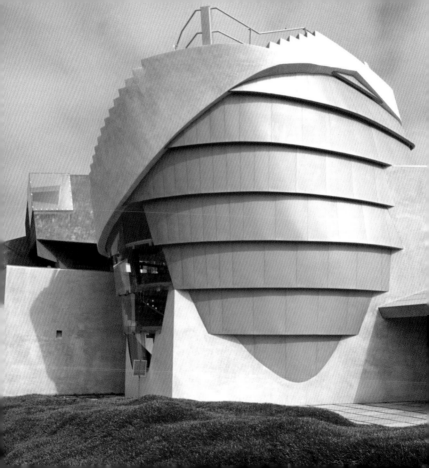

Trividia

Eric Owen Moss Architects
Kurily Szmanski Tchirkow, Inc. (SE)

1999
3524 Hayden Avenue
Culver City

www.ericowenmoss.com

The project is a renovation of an existing warehouse. A special feature is an undulating wall out of 1000 concrete blocks that are penetrated by steel windows. This detail appears simple but was extremely difficult to built, which was the architect's intent.

Bei dem Projekt ging es um die Renovierung eines bestehenden Lagerhauses. Ein besonderer Blickfang ist eine wellenförmige Wand, die aus 1000 Beton-blöcken zusammengesetzt ist und von Stahlfenstern durch-brochen wird. Dieses Detail er-scheint einfach, war aber sehr kompliziert zu bauen, was durch-aus vom Architekten so gewollt wurde.

Ce projet porte sur la rénovation d'un entrepôt préexistant. Parti-cularité spéciale : son mur on-dulé, formé de 1000 blocs de béton perforés par les baies de fenêtres en acier. Les détails pa-raissent simples à la vue, mais la réalisation s'est avérée extrê-mement difficile – ce que voulait l'architecte.

Este proyecto es la renovación de un almacén existente. Uno de los detalles especiales de este es una pared ondulada de 1000 bloques de concreto en donde ventanas de acero son penetradas. Detalle que aparen-ta ser simple, pero fue extrema-damente dificultoso de construir, lo cual fue parte de la intencion del arquitecto.

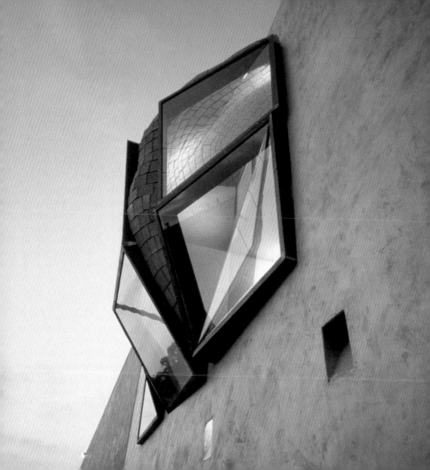

XAP

Pugh + Scarpa Architects

2002
3534 Hayden Avenue
Culver City

www.lbma.org
www.pugh-scarpa.com

XAP Corporation is an internet-based information system for new college students. This tenant improvement project had a goal and a restraint: to reflect the open, cooperative structure of the company and not to touch the existing building with the new, sculptural partitions.

XAP Corporation ist ein Internet-Informationssystem für Studienanfänger. Dieser Innenausbau hatte ein Ziel, das zugleich eine Einschränkung bedeutete: Die Innenräume sollten die offene Struktur der Firma widerspiegeln. Gleichzeitig durften die skulptural geformten Raumteiler das vorhandene Gebäude nicht berühren.

XAP Corporation est un système d'information basé sur Internet et destiné aux jeunes étudiants venant d'entrer au « College ». Ce projet d'amélioration avait un objectif qui était en même temps son frein : refléter la structure ouverte et coopérative de la société XAP sans toucher au bâtiment préexistant avec ses nouvelles partitions sculpturales.

XAP, es una corporación basada en Internet de sistemas informáticos para estudiantes universitarios de nuevo ingreso. Este proyecto de mejora se concentro en reflejar la amplitud y la cooperación estructural de la compañía sin tocar el edificio existente con las divisiones esculturales.

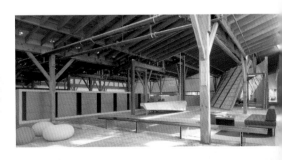

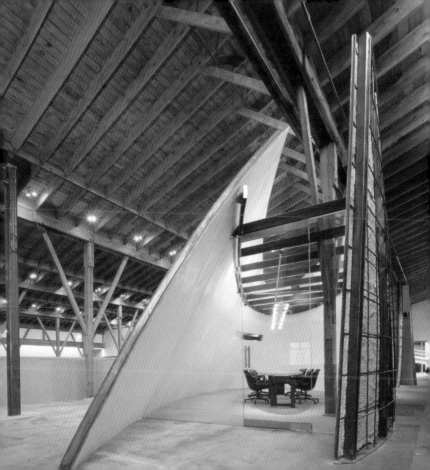

IMAX Corporation

HLW
Degenkolb Engineers (SE)

1999
3301 Exposition Boulevard
Santa Monica

www.hlw.com

This area of Santa Monica is the new Hollywood. Existing warehouses along the old train tracks are converted into film production headquarters. IMAX produces and runs big screen theaters. Their headquarter building reflects the theme of scale.

Diese Gegend von Santa Monica ist das neue Hollywood. Alte Lagerhallen entlang der ehemaligen Schienen werden in Büroräume für die Filmindustrie umgebaut. IMAX produziert und unterhält Großleinwandkinos, der Firmensitz spiegelt das Thema des Maßstabs wider.

Ce secteur de Santa Monica est le nouveau Hollywood. Les entrepôts installés le long des anciennes voies de chemin de fer ont été convertis en sièges administratifs de la société de production cinématographique. IMAX produit et exploite des cinémas grand écran. Le bâtiment du siège social reflète le thème de l'échelle.

Esta área de Santa Monica se ha convertido en el nuevo Hollywood. Donde almacenes existentes alo largo de la vieja vía del tren fueron trasformados en oficinas centrales de producción de film. IMAX produce y encarga de pantallas grandes de cine. Sus oficinas centrales reflejan la escala atraz de la idea.

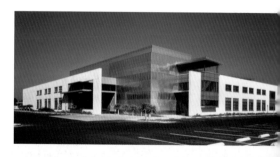

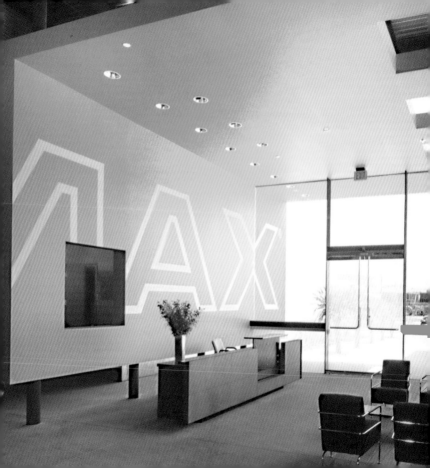

TBWA/Chiat/Day advertising offices

Clive Wilkinson Architects
John A. Martin Associates (SE)

1999
5353 Grosvenor Boulevard
Playa Vista

www.tbwachiat.com
www.clivewilkinson.com

The new headquarters of the advertisement group TBWA/Chiat/Day is the largest on the West Coast. Called the "Advertisement City" it is playful, colorful ambiance and open offices with surfboards and tent structures are designed to encourage a communicative creative working environment.

Der neue Firmensitz des Werbegiganten TBWA/Chiat/Day ist der größte an der Westküste. Er wird die „Werbestadt" genannt. Die bunte, fröhliche Atmosphäre mit offenen Büros, Surfbrettern und Zeltdächern soll eine kommunikative, kreative Zusammenarbeit fördern.

Le nouveau siège social du groupe publicitaire TBWA/Chiat/Day est le plus vaste du genre sur la West Coast. Encore appelé « Cité de la publicité », l'édifice est ludique, d'une ambiance colorée, aux bureaux ouverts sur des structures en tente avec surfboards promouvant un environnement de travail propice à la communication et à la créativité.

El nuevo headquarters del grupo TBWA/Chiat/Day de publicidad es el más grande de la Costa Oeste. Llamada la "Ciudad de Publicidad" su ambiente tan colorido y oficinas abiertas con tablas de surfear y estructuras de carpa fueron diseñados para crear un ambiente creativo y comunicativo.

Cathedral of Our Lady of the Angels

Rafael Moneo
Nabin Youssef Associates (SE)

2002
555 West Temple Street
Downtown

www.olacathedral.org

One of the largest catholic communities in the world now has a cathedral that reflects its size and its diversity. It is wonderfully crafted space with a masterful use of natural light through alabaster windows. The sculptor Robert Graham designed the bronze entry doors.

Eine der größten katholischen Gemeinden der Welt hat endlich eine Kathedrale, die ihre Größe und Vielfältigkeit widerspiegelt. Es ist ein wundervoll konzipierter Raum, der sich das Licht, das durch die Alabasterfenster einfällt, meisterhaft zunutze macht. Der Bildhauer Robert Graham entwarf die bronzenen Eingangstüren.

L'une des plus vastes communautés catholiques dans le monde possède maintenant une cathédrale qui reflète son ampleur et sa diversité. Espace merveilleusement ouvré, dans lequel une main de maître apporte la lumière naturelle par des vitraux d'albâtre. Le sculpteur Robert Graham a conçu les portes en bronze.

La dimensión en tamaño de esta catedral da a reflejar a esta diversa comunidad católica; Siendo una de las más grandes del mundo. El espacio esta perfectamente detallado e iluminado con el uso de luz natural que entra atravez de las ventanas de alabastro. Las puertas principales de bronce fueron diseñadas por el escultor Robert Graham.

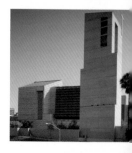

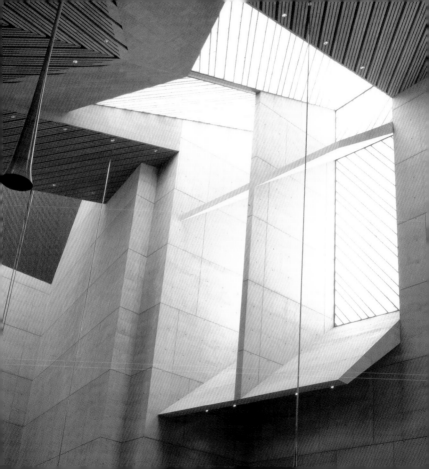

Science Center School

Morphosis
Engelkirk Engineers (SE)

2004
700 State Drive
Downtown

www.californiasciencecenter.org
www.morphosis.net

Situated in Exposition Park, the school had to respond to a busy street and a historic building, the Armory. One part of the new building is tucked away under layers of lifted landscape to "test the boundaries between land and the tectonic".

Die Schule liegt im Exposition Park und muss sich auf eine laute Straße sowie einen historischen Bau, das Zeughaus, reagieren. Ein Teil des neuen Gebäudes ist unter Schichten von nach oben gehobener Landschaft geschoben, „um die Grenzen zwischen Baugrund und Tektonik auszuloten".

Située dans l'Exposition Park, cette école devait faire face à une rue très trafiquée et à un bâtiment historique, l'Armurerie. Une partie du nouveau bâtiment s'est repliée sous des couches de terrain surélevé artificiellement, « pour tester les limites entre la terre et la tectonique ».

Ubicada en Exposition Park, esta escuela tuvo que responder a la calle tan transitada y edificio histórico, la Armonía. Parte del edificio nuevo se esconde bajo las capas de la condición urbana para "comprobar las barreras entre la tierra y lo teutónico".

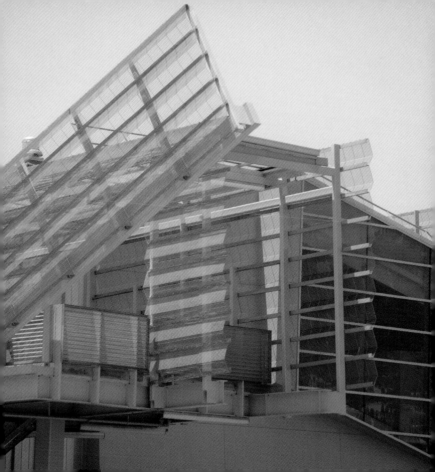

SCI-ARC

Southern California Institute of Architecture

Gary Paige

2004
960 East Third Street
Downtown

www.sciarc.edu

Recently, SCI-ARC, the renowned architecture school, had to move again. The new facility, an old train depot and loading dock, was gutted and remodeled with steel-grate mezzanines, concrete floors and an industrial esthetic that suits the location.

Unlängst musste SCI-ARC, die bekannte Architekturschule, wieder umziehen. Die neue Unterkunft, ein altes Bahndepot und Ladedock, wurde vollkommen entkernt und mit Zwischengeschossen aus Stahlgittern und Betonböden in einer industriellen Ästhetik ausgestattet, die in die Umgebung passt.

Il a récemment fallu que la SCI-ARC, école d'architecture réputée, déménage à nouveau. Son nouveau domicile, un dépôt ferroviaire et un dock de transbordement, a été vidé de son contenu puis remodelé avec des mezzanines à ossature en acier, des planchers en béton et une esthétique industrielle qui s'harmonise bien avec le site.

Recientemente, La renovación de la universidad de arquitectura tuvo que moverse de nuevo. La nueva instalación, un antiguo almacén de trenes y una plataforma de carga fueron reformados con placas de acero de entresuelo, pisos de hormigón y una estética industrial para reflejar la zona industrial en la que esta se encuentra.

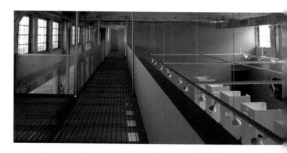

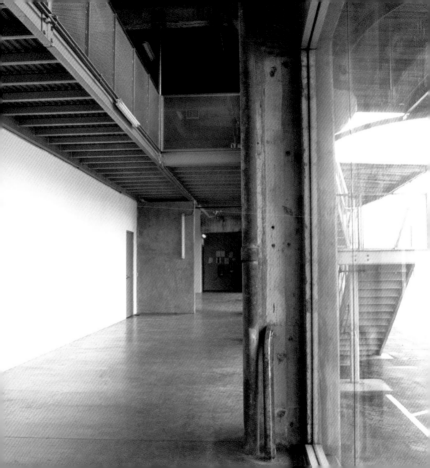

Walt Disney Concert Hall

Frank O. Gehry
John A. Martin Associates (SE)

2003
111 South Grand Avenue
Downtown

wdch.laphil.com
www.frank-gehry.com

Local architect Frank Gehry has designed one of his undulating masterpieces for Los Angeles. This stunning solitaire, clad in stainless steel panels, has an organic and dynamic shape that continues on the inside with rich hardwood paneling in swooping curves.

Der einheimische Architekt Frank Gehry hat für Los Angeles eines seiner geschwungenen Meisterwerke entworfen. Dieser verblüffende Solitär ist mit Edelstahlplatten verkleidet und hat eine organische, dynamische Form, die sich im Innenraum mit wild gekurvten Hartholzpaneelen fortsetzt.

Frank Gehry, un architecte local, a conçu pour Los Angeles l'un de ces chef-d'œuvre dont lui seul a le secret. Ce solitaire étonnant, habillé en panneaux d'acier inoxydable, a une forme organique et dynamique qui se poursuit à l'intérieur par de riches panneaux en bois dur aux courbes inattendues.

Frank Gehry, un arquitecto local de Los Angeles, diseñó otra de sus obras maestros de ondulaciones. Esto proyecto único esta cubierto de paneles de acero formando una forma orgánica y dinámica que continua en el interior con curveados paneles de madera.

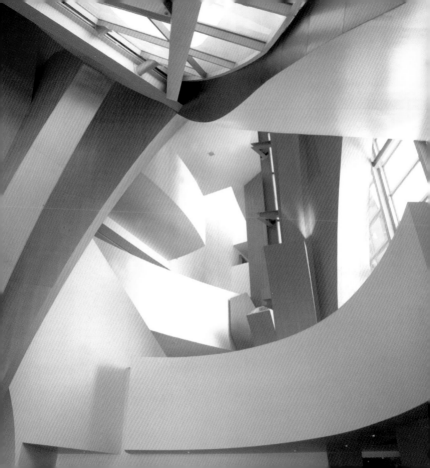

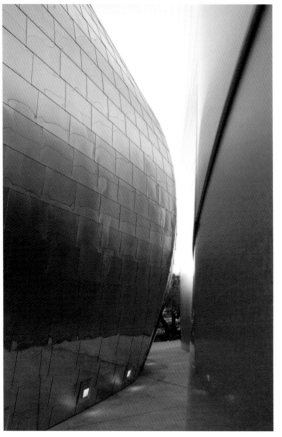
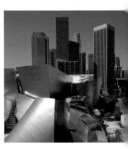
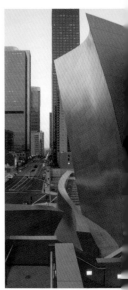

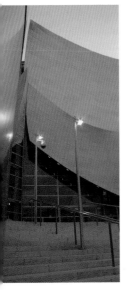

Collins Gallery

Tighe Architecture
Joseph Perazzelli (SE)

2002
8818 Dorrington Avenue
West Hollywood

www.tighearchitecture.com

This is the residence of an art collector who wanted a living space with a separate art gallery to show his art and to host shows of new artists. A reflecting pool continues the light-filled space of the gallery into the garden.

Dies sind das Wohnhaus eines Kunstsammlers, der einen Wohnbereich mit anschließender Galerie wollte, um seine Kunstsammlung zu zeigen und Werke neuer Künstler auszustellen. Ein spiegelndes Wasserbecken scheint den lichtdurchfluteten Galerieraum in den Garten hinaus fortzusetzen.

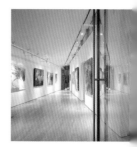

Et voici la résidence d'un collectionneur d'art qui souhaitait à la fois un espace résidentiel et une galerie séparée où exposer son art et accueillir un temps les œuvres de nouveaux artistes. Une piscine réfléchissante prolonge vers le jardin l'espace rempli de lumière de la galerie.

Esta es la residencia de un coleccionista de artes quien deseaba un espacio habitacional con una galería de arte separada, para exhibir su arte y exhibir a nuevos artistas. Una piscina reflejada continúa este ligero espacio de la galería hacia el jardín.

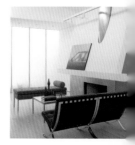

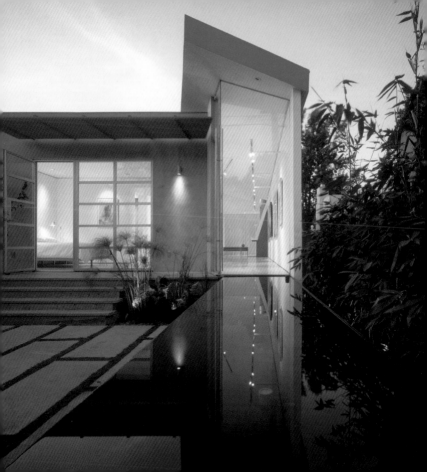

MOCA
Pacific Design Center

Cesar Pelli & Associates Architects

1999
8687 Melrose Avenue
West Hollywood

www.moca.org
www.cesar-pelli.com

This is the second satellite of the Museum of Contemporary Art. Located in the courtyard of the Pacific Design Center, the exhibits are usually about design, architecture or photography and are housed in the Feldman Gallery or in temporary tent structures.

Dies ist die zweite Außenstelle des Museums of Contemporary Art. Passend zur Lage im Innenhof des Pacific Design Centers haben die Ausstellungen meist mit Design, Architektur oder Fotografie zu tun. Sie sind in der Feldman Gallery oder in temporären Zeltbauten untergebracht.

Voici la seconde antenne du Museum of Contemporary Art. Situés dans le patio du Pacific Design Center, les objets exposés ont habituellement trait au design, à l'architecture et à la photographie, et sont logés dans la Feldman Gallery ou sous un campement provisoire.

Ubicado en el jardín céntrico del Pacific Design Center, se encuentra el segundo satélite del Museo de Arte Contemporánea. Exhibiendo usualmente diseño, arquitectura o fotografía, tomando lugar en la galería de Feldman o en estructuras temporales.

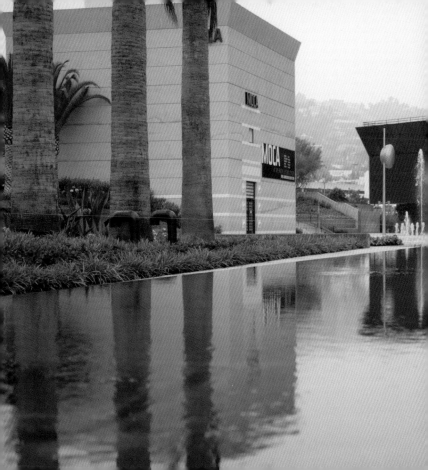

Harvard Westlake School

Michael Maltzan Architecture
King Benioff Steinmann King (SE)

1998
3700 Coldwater Canyon Avenue
North Hollywood

www.harvardwestlake.com
www.mmaltzan.com

The new Feldman Center for the Arts is located on an existing school campus. An arrangement of buildings around a courtyard houses the art department. The simple white surfaces draw attention to the delicately sculpted shapes and their relationship to the site.

Das neue Feldman Center für Kunsterziehung ist in ein vorhandenes Schulgelände eingefügt. Eine Ansammlung von Gebäuden um einen Innenhof beherbergt die neuen Klassenräume und Werkstätten für die künstlerischen Fächer. Die einfachen weißen Oberflächen betonen die skulpturalen Formen und ihr Verhältnis zum Gelände.

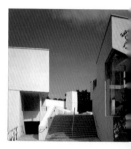

Le nouveau Feldman Center for the Arts est situé sur un campus scolaire préexistant. Un ensemble d'immeubles entourant une cour héberge le département des beaux-arts. La surface, simple par sa blancheur, attire l'attention vers des formes délicatement sculptées et sur leur relation avec le site.

El centro nuevo de Feldman para las artes esta ubicado en una escuela existente. La organización de los edificios alrededor del patio adopta el departamento de arte. Las simples superficies blancas atraen atención a la formas delicadamente esculturadas y su relación con el emplazamiento.

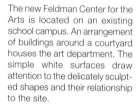

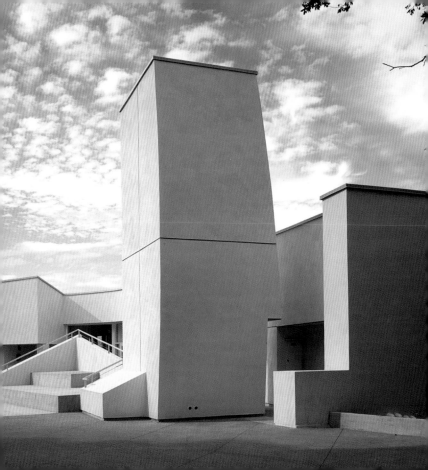

Getty Center

Richard Meier & Partners, Architects
Emmet L. Wemple & Associates (SE)

1997
1200 Getty Center Drive
Brentwood

www.getty.edu
www.richardmeier.com

One of the most important new museums of the last decade, the Getty Center sits on top of a hill with panoramic views. The classically modern shapes are softened by the use of textured travertine panels that give a feeling of permanence to the building.

Eines der bedeutendsten Museen der letzten Jahre, das Getty Center, sitzt auf einer Hügelspitze mit Panorama-Aussicht. Eine rohe Travertinverkleidung lässt die Formen der klassischen Moderne weicher erscheinen und verleiht dem Gebäude eine Aura von Beständigkeit.

L'un des plus importants nouveaux musées ouverts depuis la décennie passée, le Getty Center repose au sommet d'une colline et offre plusieurs vues panoramiques. Ses formes d'un modernisme classique sont adoucies par l'emploi de panneaux de travertin texturé conférant un sentiment de pérennité à l'édifice.

El Getty Center, uno de los museos más importantes de última década, se asienta en una montaña con vistas panorámicas. Presentando una modernidad clásica en las formas ablandadas con el uso de paneles travertin con textura, haciendo el edificio permanente.

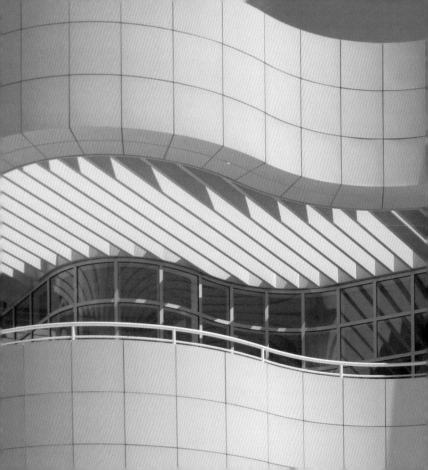

First Presbyterian Church

Abramson Teiger Architects
Soly Yamini Engineering (SE)

2002
4963 Balboa Avenue
Encino

www.abramsonteiger.com

The original church had a dark and depressing interior. The architects were hired to design a space that would raise the congregation's spirit to a higher level. They remodeled the space and added skylights that fill the church with light.

Die ursprüngliche Kirche war in ihrem Innern dunkel und deprimierend. Die Architekten wurden engagiert um einen Raum zu entwerfen, der die Spiritualität der Gemeinde erhöhen sollte. Sie renovierten den Innenraum und fügten Oberlichter ein, welche die Kirche mit Licht durchfluten.

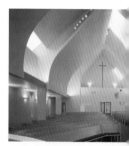

L'église présentait à l'origine un intérieur obscur et déprimant. Les architectes ont été chargés de concevoir un espace qui élèverait le moral de la congrégation. Ils ont remodelé l'espace et ajouté des baies faîtières qui inondent l'église de lumière.

Los arquitectos fueron contratados para diseñar un espacio que elevara el espíritu de la congregación, la cual tenía un interior deprimente de color oscuro originalmente; fue necesario remodelar el espacio y adherir traga cielos, iluminando la iglesia desde fuera.

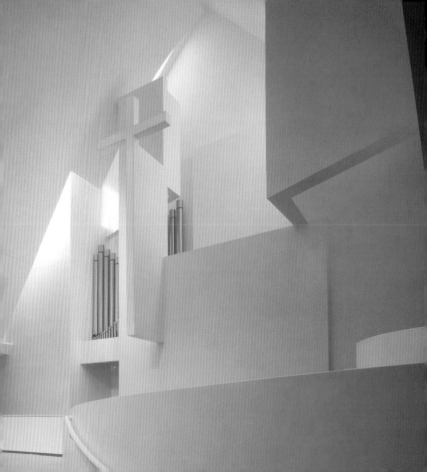

Long Beach Museum of Art

Frederick Fisher and Partners
Gordon Polon Engineering (SE)

1999
307 Cliff Drive
Long Beach

www.lbma.org
www.fisherpartners.net

The Long Beach Museum of Art needed to expand its facilities. Frederick Fisher and Partners designed a master plan that integrated the existing Arts and Crafts villa into a museum campus. It now consists of the original villa, a new building and the carriage house.

Das Long Beach Museum of Art musste seine Räumlichkeiten erweitern. Frederick Fisher and Partners lieferten einen Masterplan, der die bestehende Arts-and-Crafts-Villa in einen Museumscampus integriert. Dieser besteht nun aus der alten Villa, einem neuen Gebäude und dem ehemaligen Kutscherhaus.

Le Long Beach Museum of Art manquait de place. Le cabinet Frederick Fisher and Partners a conçu un plan général intégrant la villa des arts et de l'artisanat dans un campus de musée. Celui-ci comprend donc désormais la villa originale, un bâtiment neuf et la remise pour voiture à chevaux.

El Museo de Arte de Long Beach necesitaba expandir sus instalaciones. Frederick Fisher and Partners diseñaron un plan maestro donde lograron integrar el movimiento de "arts and crafts" existente de la villa al campus del museo. Ahora consiste de la villa original, un edificio nuevo y una casa de carruaje.

Art Center College of Design
South Campus

Daly Genik Architects

2004
950 South Raymond Avenue
Pasadena

www.artcenter.edu
www.dalygenik.com

Art Center College of Design needed more space and found it in an existing building that formerly housed a wind tunnel testing facility. The architect's biggest challenge was to bring light into the studios and gallery spaces through skylights and light wells.

Das Art Center College of Design brauchte mehr Platz und fand ihn in einem bestehenden Gebäude, in dem früher Windkanalversuche durchgeführt wurden. Die größte Herausforderung für die Architekten war es, durch Oberlichter und Lichtschächte mehr Helligkeit in die Ateliers und Galerien zu bringen.

L'Art Center College of Design avait lui aussi besoin de s'étendre, ce qu'il a fait dans un bâtiment préexistant qui hébergeait par le passé un centre d'essais en soufflerie. Le plus grand défi auquel l'architecte dut faire face consistait à faire entrer la lumière dans les studios et les espaces galerie par des lumidômes et abat-jour.

Art Center College of Design carecía de espacio y encontró un edificio existente que solía ser una facilidad de túneles de viento. Una de las dificultades mas grandes del arquitecto fue guiar la luz natural hacia los talleres y galerías atravez de los tragacielos.

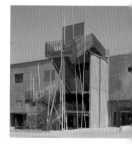

Kidspace Children's Museum

Michael Maltzan Architecture

2005
480 North Arroyo Boulevard
Pasadena

www.kidspacemuseum.org
www.mmaltzan.com

The museum is located on a sloping site with three historical buildings. The new buildings will redefine the organization of the museum, allowing for a linear procession as well as "short cuts" for a child friendly environment.

Das Museum liegt auf einem abfallenden Gelände, auf dem schon drei historische Gebäude stehen. Die neuen Bauten werden die Wegführung des Museums neu organisieren und sowohl einen ausführlichen Rundgang als auch kinderfreundliche Abkürzungen ermöglichen.

Ce musée se trouve sur un s en pente et comprend tr bâtiments historiques. Les n velles constructions redéfinir l'organisation du musée, p mettant une progression linéa du public ainsi que de pren des raccourcis pour que l'er ronnement soit agréable a enfants.

El museo esta ubicado en un emplazamiento inclinado alrededor de tres edificios históricos. Los edificios nuevos le dan una nueva definición a la organización del museo, permitiendo un proceso lineal al igual que formas de cortar camino para un ambiente amigable para niños.

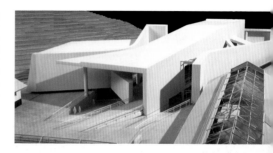

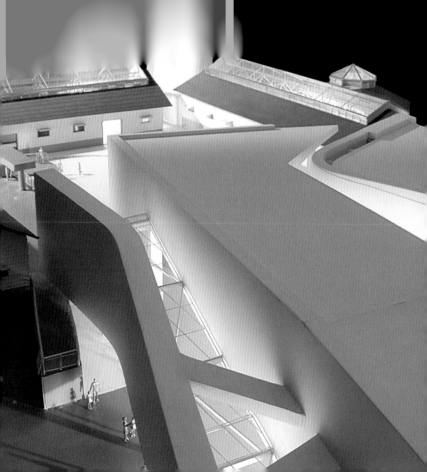

Pasadena Christian Center

Tolkin & Associates Architecture
Karl Blette (SE)

2001
2588 East Colorado Boulevard
Pasadena

www.tolkinarchitecture.com

The existing space was a theater with a lamella roof. The architect wanted the Pentecostal tradition of "ecstatic" worship that is free from symbolic representation to be reflected in the free forms of the new rooms that match the roof without its stark geometry.

Der vorgegebene Raum war ein altes Theater mit einem Lamellendach. Der Architekt wollte, dass sich die „ekstatische" Art des Gottesdienstes dieser Pfingstgemeinde, die ohne symbolische Repräsentation auskommt, in den freien Formen der neuen Räume widerspiegelt, die zu dem bestehenden Dach mit seiner wenig strengen Geometrie passen.

L'espace d'avant était un théâtre doté d'une toiture en lamelle. L'architecte voulait respecter la tradition d'adoration « extatique » propre à la communauté pentecôtale, exempte de représentations symboliques et reflétée dans les formes libres des nouvelles salles, en harmonie avec le toit sans reprendre toutefois sa puissante géométrie.

Este espacio era un teatro con techo de lámina. El arquitecto decidió seguir la tradición Pentecostal de culto "ecstatic", libre de representación simbólica que seria reflectada en las formas libres de los cuartos nuevos que coincidieran con el techo sin seguir su geometría.

Pasadena Museum
of Californian Art

MDA Johnson Favaro
John H. Haigh and Associates (SE)

2002
490 East Union Street
Pasadena

www.pmcaonline.org
www.johnsonfavaro.com

The PMCA is a privately funded public museum for Californian Art. Located in an urban context, the cube-like shape has a parted "drapery fold" facade that reveals the entry to the building. This theme of subtle forms leading the way continues on the inside.

Das PMCA ist ein privat finanziertes öffentliches Museum für Kalifornische Kunst. Inmitten einer städtischen Umgebung hat der kubusartige Bau eine losgelöste „Vorhangfalten"-Fassade, die den Eingang ins Gebäude verbirgt. Dieses Thema der subtilen Wegeführung setzt sich im Inneren fort.

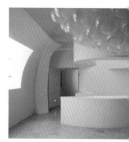

Le PCMA est un musée public d'art californien géré à l'aide de fonds privés. Situé en milieu urbain, ce véritable cube présente une façade divisée en « tentures pliées » révélant l'entrée vers l'édifice. Le thème ainsi entamé des formes subtiles montrant le chemin se poursuit à l'intérieur.

El PCMA es un museo público fundado privadamente para el Arte de California. Ubicado en un contexto urbano; la forma de cubo consiste de una fachada de "doblez colgante" que revela la entrada al edificio. Este concepto de formas generosas guía el camino continuando en el interior.

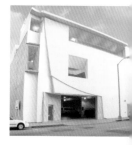

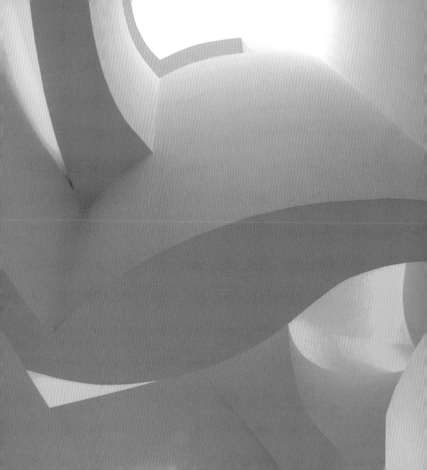

Diamond Ranch High School

Morphosis
Ove Arup & Partners (SE)

2000
100 Diamond Ranch Drive
Pomona

www.pusd.org
www.morphosis.net

The school shape takes its cue from the surrounding landscape. To blur the division between passive site and active building, a "canyon" cuts through the three classroom clusters like a fault line. An amphitheater is embedded in the hillside to use the natural topography.

Der Form der Schule geht auf die landschaftliche Umgebung ein. Um die Unterscheidung in passive Erde und aktiven Bau zu verwischen, ist ein „Canyon" wie ein tektonischer Graben durch die drei Cluster der Klassenräume geschnitten. Ein Amphitheater ist in den Hang eingebettet und macht sich die natürliche Topografie zunutze.

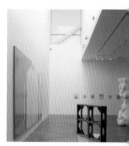

La forme de l'école prend exemple sur celle du paysage environnant. Pour estomper la division entre le site passif et le bâtiment actif, un « canyon » entaille les trois blocs de classes comme une véritable ligne de faille. Un amphithéâtre est niché à flanc de colline pour profiter de cette aubaine topographique.

La forma constituyente de este proyecto depende en sus alrededores. Para crear la división entre el emplazamiento pasivo y el edificio activo, un "cañón" atraviesa los tres conjuntos de salones como si fuese una línea inactiva. Un anfiteatro se hace parte de la montaña para hacer uso de la topografía natural.

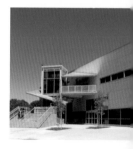

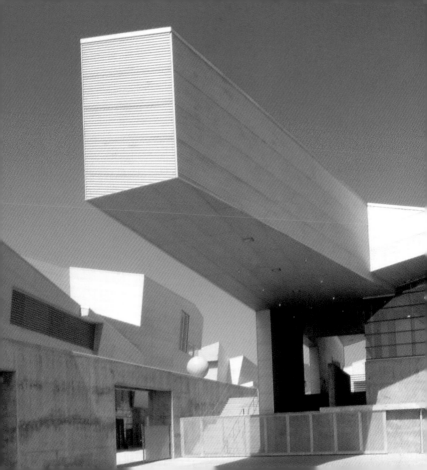

Metro Station
Vermont &
Santa Monica Boulevard

Ellerbe Becket, Yazdani Studio
Martin + Huang International (SE)

2000
1015 North Vermont Avenue
Downtown

www.mta.net
www.ellerbebecket.com
www.yazdanistudio.com

Contrary to popular belief Los Angeles does have a subway system. It does not run very far, but the few stations are designed with attention to architecture and art that is unusual for a public transportation system. This is its most successful example.

Allen Vorurteilen zum Trotz hat Los Angeles eine Untergrundbahn. Ihr Netz ist nicht sehr groß, aber ihre wenigen Haltestellen wurden mit einem ungewöhnlich hohen Anspruch an Architektur und Kunst entworfen. Diese Metro-Station ist das gelungenste Beispiel.

Contrairement aux croyances populaires, Los Angeles possède de bel et bien des lignes de métro. Elles ne vont pas très loin mais les stations ont été conçues avec une attention, une architecture et un art que l'on n'a pas l'habitude de rencontrer dans un système de transport public. En voici l'exemple le mieux réussi.

Opuesto a la creencia popular, Los Angeles tiene un sistema subterráneo de transportación. Las pocas estaciones existentes han enfocado su diseño en arquitectura y arte, algo inusual de un proyecto público de transportación. Este se presenta como uno de los mejores ejemplos.

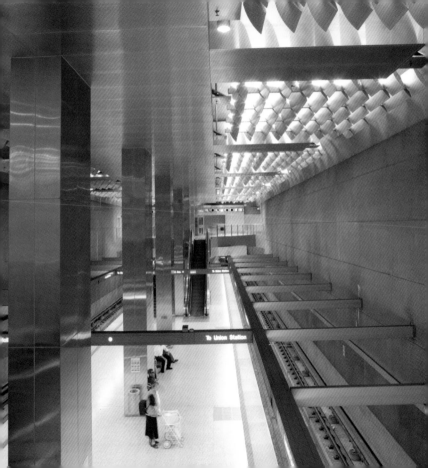

L.A. Police Department

The Vortex Plaza

Joel Breaux, BJ Krivanek (Public Artist)

2002
150 North Los Angeles Street
Downtown

www.lapdonline.org

This plaza in front of the police department is a representation of the 911 system, emergency number. The dark polished surface elliptical columns reflect the city in a malignant way, the words on the outer wall, suggesting the police department's role, and the inscriptions on the glass cylinder, symbolizing the fragile moment when the person calls the 911 system.

Der Platz vor der Polizeistation soll das Notrufsystem darstellen. Die dunkel polierten, im Querschnitt elliptischen Säulen sollen die bedrohliche Stadt darstellen, die Worte auf der Außenmauer die Rolle der Polizei und die Worte auf dem Glaszylinder den verletzlichen Augenblick, in dem eine Person die Notrufnummer 911 wählt.

La place bordant le commissariat de police est censée représenter le système d'appel d'urgence. Les colonnes polies sombres, de section elliptique, représentent la ville menaçante, les mots sur le mur extérieur le rôle de la police et ceux sur le cylindre en verre cet instant de vulnérabilité où l'appelant compose 911, le numéro d'urgence.

Esta plaza frente la estación de policía representa el sistema de 911, el número de emergencia. Reflejando la ciudad de manera malevolente con columnas elípticas de color oscuro, sugiriendo la posición de la policía con palabras escritas en la pared y de igual forma, representando el frágil momento en el que la persona marca el 911.

Kodak Theatre

Rockwell Architecture

2001
6801 Hollywood Boulevard
West Hollywood

www.kodaktheatre.com
www.rockwellgroup.com

The Academy Awards Cermony is the most important event of the year in Los Angeles. The Rockwell Group designed a theater space that had a large entrance, for the red-carpet show and an impressive interior for a show that centers on the audience as much as on the stage.

Die Oscar-Verleihung ist in Los Angeles der Höhepunkt des Jahres. Die Rockwell-Group hat ein Theater entworfen, das einen großen Eingang für Auftritte auf dem Roten Teppich und einen imposanten Innenraum hat, da während der Zeremonie der Zuschauerraum eine ebenso wichtige Rolle spielt wie die Bühne.

A Los Angeles, l'Academy Awards Ceremony est le plus important événement de l'année. C'est le Rockwell Group qui a conçu cet espace cinématographique avec une vaste zone d'entrée permettant aux stars de défiler sur le tapis rouge. A l'intérieur, tant la scène que le public animent le spectacle.

Una de las ceremonias más importantes de Los Angeles es la Academia de Reconocimientos. Fue el Rockwell Group que tomo cargo de diseñar un teatro con una entrada amplia para el evento de carpeta roja con un interior impresionante que centra la audiencia tanto como la plataforma de presentación.

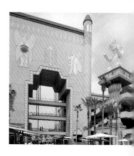

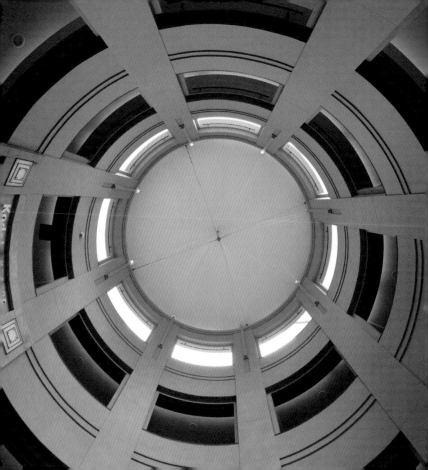

Plummer Park
Community Center

Koning Eizenberg Architecture
KPFF Consulting Engineers (SE)

2001
7377 Santa Monica Boulevard
West Hollywood

www.kearch.com

The City of West Hollywood is very active in promoting a diverse and harmonious community. This community center addition sits in a park with playgrounds, tennis and basketball courts and a popular farmers' market.

Die Stadt West-Hollywood ist sehr daran interessiert, eine vielseitige und harmonische Gemeinde zu sein. Dieser gelungene Anbau an ein Gemeindehaus liegt in einem Park mit Spielplätzen, Tennis- und Basketballanlagen und einem beliebten Wochenmarkt.

La cité de West Hollywoo promeut très activement la d versité et l'harmonie de sa com munauté. Cet ajout au centr communal repose dans un par doté de terrains de jeu, courts d tennis et de basket, ainsi qu d'un marché fermier très popu laire.

La activa ciudad de West Hollywood, ha creado una armonía diversa en su comunidad. Cuya adición se asienta en un parque con áreas recreativas, canchas de tenis y basketball y un mercado popular.

Civic Center Drive

Barton Myers Associates, Inc.

2001
9350 Civic Center Drive
Beverly Hills

www.bartonmyers.com

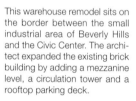

This warehouse remodel sits on the border between the small industrial area of Beverly Hills and the Civic Center. The architect expanded the existing brick building by adding a mezzanine level, a circulation tower and a rooftop parking deck.

Diese umgebaute Lagerhalle liegt zwischen einem kleinen Industriegebiet von Beverly Hills und dem Rathaus. Der Architekt vergrößerte den bestehenden Klinkerbau, indem er ein Zwischengeschoss, einen Zufahrtsturm und Parkflächen auf dem Dach hinzufügte.

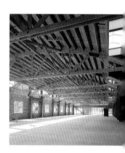

Cet entrepôt réfectionné se trouve sur la bordure séparant la petite zone industrielle de Beverly Hills et le Civic Center. L'architecte a agrandi le bâtiment en briques préexistant en lui ajoutant un niveau en mezzanine, une tour d'accès en voiture et un niveau de parking sur le toit.

La remodelación de este almacén se asienta justo al borde, entre la zona industrial de Beverly Hills y el Centro Civico. El arquitecto expandió el edificio de ladrillo existente adhiriendo un nivel mezanine, una torre de circulación y un estacionamiento en el techo.

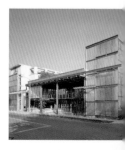

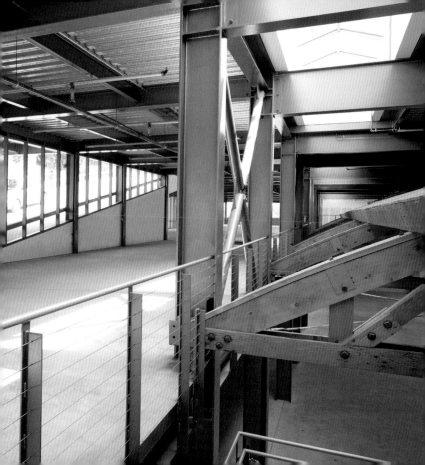

LAX light sculptures

Paul Tzanetopoulos
Ove Arup & Partners (SE)

2000
Century Boulevard
Airport

www.lawa.org
www.tzap-art.com

LAX is not exactly an inspiring piece of architecture. Until now, the central restaurant building, the "spider" by architect Paul Williams was its most significant feature. The new LAX light sculptures have definitely upgraded the airport experience, especially for nighttime arrivals.

Der Flughafen LAX ist nicht gerade ein aufregendes Architekturerlebnis. Bis jetzt war das zentral gelegene Restaurantgebäude „Spider" von Paul Williams der einzige Lichtblick. Die neuen LAX Lichtsäulen sind nun eine wirkliche Bereicherung, besonders für Besucher, die nachts ankommen.

LAX n'est pas exactement ce qu'on appellerait un objet architectural inspirateur. Jusqu'à présent, l'édifice central hébergeant le restaurant, « spider » de l'architecte Paul Williams, constituait son trait le plus marquant. Les nouvelles sculptures légères de LAX rehaussent à coup sûr le vécu de cet aéroport, surtout lorsqu'on y atterrit la nuit.

LAX no es exactamente una pieza de inspiración de arquitectura. El restaurante central del edificio, "spider" del arquitecto Paul Williams fue hasta ahora la caracteristica más significativa. Las esculturas de luz instaladas han definitivamente modificado la experiencia de estar en el aeropuerto, especialmente por las noches.

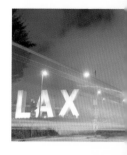

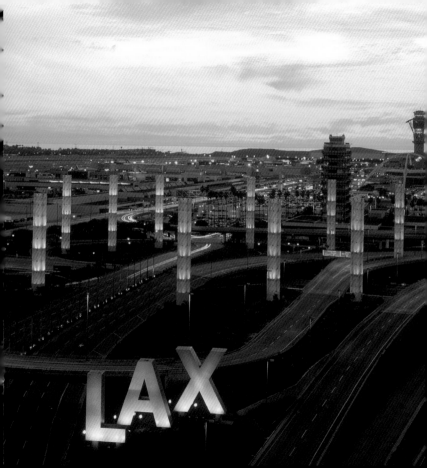

to stay . hotels

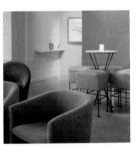
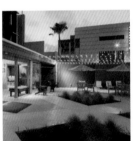
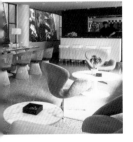
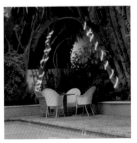
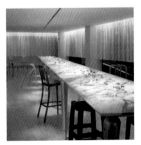

The Standard

Downtown LA

Shawn Hausman, Koning Eizenberg Architecture

2002
550 South Flower Street
Downtown

www.standardhotel.com
www.kearch.com

Originally an office building, the Standard is one of the successful conversions where just enough has been done to upgrade the look while preserving the former elegance. It is a challenge to guess what is original and what is new.

Ehemals ein Bürogebäude, ist das Standard eines jener gelungenen Umbauprojekte, bei dem nur soviel getan wurde, um sein Erscheinungsbild zu aktualisieren, während die ursprüngliche Eleganz bewahrt blieb. Es ist nicht leicht festzustellen, was original und was neu ist.

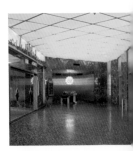

Bâtiment de bureaux à l'origine, le Standard est une reconversion réussie où l'on a juste fait ce qu'il fallait pour rehausser le look tout en préservant l'élégance originelle. Bien difficile de dire ce qui est d'origine et ce qui neuf.

Un edificio de oficinas, fue reformado como el Standard, convirtiéndose en uno de los proyectos más sobresalientes, recobrando su estilo y preservando su propia elegancia. Sería un talento reconocer lo original y lo nuevo.

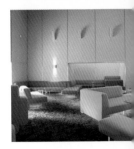

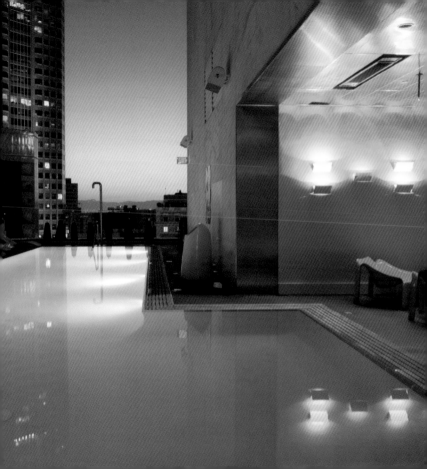

Elan Hotel

Abramson Teiger Architects

2000
8435 Beverly Boulevard
Los Angeles

www.elanhotel.com
www.abramsonteiger.com

A former convalescent home, this building has been completely reconfigured into a minimal yet comfortable hotel. The downstairs lobby is completely transparent to the street, making it look like the many furniture stores along Beverly Boulevard.

Dieses Gebäude, das ehemals eine eine Reha-Klinik beherbergte, wurde komplett in ein minimalistisches, aber wohnliches Hotel verwandelt. Die Eingangshalle ist zur Straße hin vollverglast, so dass sie aussieht wie eines der vielen Möbelgeschäfte auf dem Beverly Boulevard.

Ancienne maison de convalescence, cet édifice a été entièrement reconfiguré en un hôtel minimaliste mais néanmoins confortable. Le foyer au bas des escaliers est entièrement transparent en direction de la rue et donne l'impression qu'il s'agit de l'un des nombreux magasins d'ameublement rencontrés le long de Beverly Boulevard.

La antigua casa de convalecencia, ha sido completamente configurada como hotel minimalistico. El lobby del primer piso es completamente transparente hacia la calle, dándole un look como las tiendas de muebles a lo largo del Beverly Boulevard.

Sunset Marquis
Hotel & Villas

Oliva Villaluz

2002
1200 Alta Loma Road
Hollywood

www.sunsetmarquishotel.com

Hidden in a quiet side street near the Sunset Strip, the Sunset Marquis is popular with musicians and record producers. Along with the usual amenities, they also offer a recording studio and a screening room to accommodate their guests. One of the coolest bars, the Whiskey Bar, is on the premises.

Das Sunset Marquis versteckt sich in einer ruhigen Seitenstraße des Sunset Strip und ist besonders bei Musikern und Plattenproduzenten beliebt. Neben den üblichen Annehmlichkeiten steht auch ein Aufnahmestudio und ein Vorführraum zu Verfügung. Eine der beliebtesten Bars, die Whiskey Bar, befindet sich gleich im Haus.

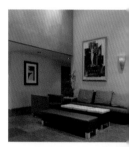

Caché dans une rue latérale proche du Sunset Strip, le Sunset Marquis est populaire chez les musiciens et producteurs musicaux. Outre le confort attendu d'un hôtel, il comporte aussi un studio d'enregistrement et une salle de projection où recevoir les hôtes. L'un des bars les plus cools, le Whiskey Bar, se trouve sur les lieux.

Escondido en una calle silenciosa cerca de Sunset strip, se encuentra Sunset Marquis, conocido popularmente con músicos y productores de discos. Con los servicios usuales ofreciendo un estudio de grabación y un cuarto de proyección para acomodar a sus invitados. Uno de los bares más populares, el Whiskey Bar, esta establecido en el mismo local.

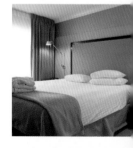

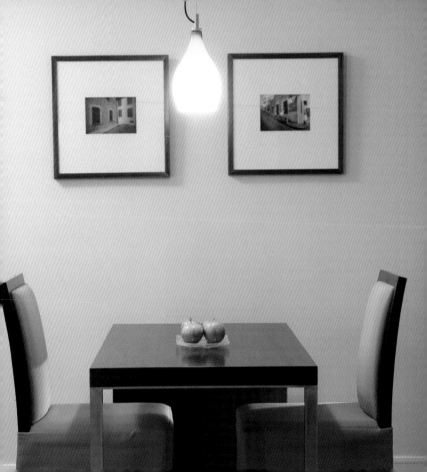

Mondrian

Philippe Starck

1997
8440 Sunset Boulevard
West Hollywood

www.morganshotelgroup.com
www.philippe-stark.com

The Mondrian was the first Los Angeles designer hotel. A mix of stark white interiors with oversized objects and a softer beach feeling on the terrace makes this a perfect reflection of Los Angeles style: elegant and edgy yet relaxed.

Das Mondrian war das erste Design-Hotel in Los Angeles. Eine Mischung aus gänzlich weißen Innenräumen mit überdimensionalen Objekten und einer entspannteren Strandatmosphäre auf der Terrasse macht es zu einem perfekten Beispiel für den typischen Stil von Los Angeles: elegant und innovativ, aber entspannt.

Le Mondrian a été le premier hôtel de concepteur à ouvrir ses portes à Los Angeles. Un mix d'intérieurs très blancs et d'objets surdimensionnés, plus une ambiance plage adoucie sur la terrasse en font le reflet parfait du style Los Angeles : élégant, aux contours très tranchés mais décontracts.

Mondrian fue uno de los primeros hoteles donde se aplico el diseñó en Los Angeles. Una mezcla de interiores blancos con objetos de tamaño grande yun ligero toque playero en la terrazo, crea un ambiente que refleja el estilo de Los Angeles perfectamente: elegante e innovador, pero relajante.

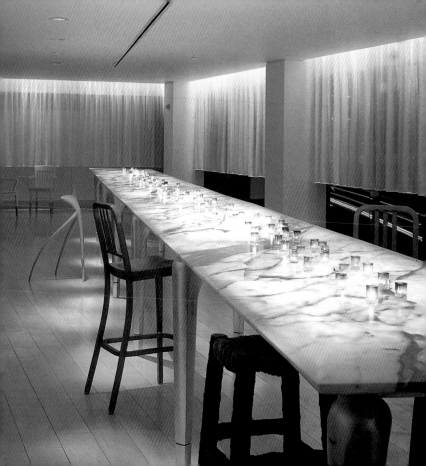

Farmer's Daughter

Dean Larkin Design
Enco Design (SE)

2004
115 South Fairfax Avenue
Mid Wilshire

www.farmersdaughterhotel.com
www.deanlarkindesign.com

A former drab motel, right across the street from the Farmers Market got a facelift. The name was too cute to change and the décor followed suit. From haystacks in the lobby to the brightly colored rooms, the hotel is a witty interpretation of a farm theme in a 50's shell.

Ein ehemaliges düsteres Motel gegenüber dem Farmers Market erhielt eine Schönheitskur. Der Name war zu niedlich, um ihn zu ändern, und diente als Inspiration für die Innenausstattung: Von Heuballen in der Eingangshalle bis zu den Zimmern mit ihren leuchtenden Farben ist das Hotel eine gewitzte Interpretation des Farm-Themas in einem 50er-Jahre-Gehäuse.

Cet ancien motel sans charm exactement en face de Farme Market de l'autre côté de la ru vient de recevoir un lifting. L nom était trop médiatique po le changer, et le décor à la su te. Des meules de foin dans foyer aux chambres de couleu claires, cet hôtel est l'interprét tion amusante du thème pays style années 50.

Un antiguo motel monótono, al cruzar la calle del Farmers Market fue reformado; adaptando la decoración al nombre original de la misma manera. Desde pajar en el vestíbulo a las coloridas habitaciones, el hotel es una ingeniosa interpretación de un concepto de una graja en un caparazón de los años 50.

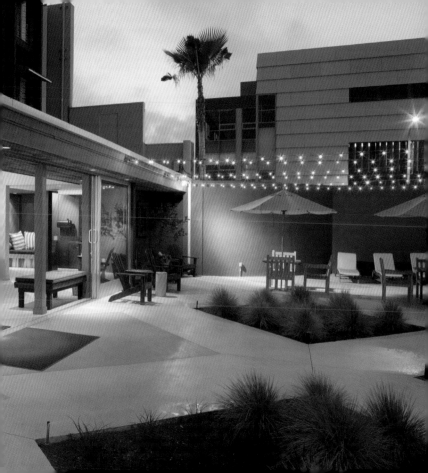

Crescent Hotel

Dodd Mitchell Design

2003
403 North Crescent Drive
Beverly Hills

www.crescentbh.com
www.doddmitchell.com

Interior designer Dodd Mitchell has transformed an old but charming hotel into a beautiful, intimate boutique hotel, right in downtown Beverly Hills. The small restaurant and the living-room comfortable lobby make you feel as if you are staying with stylish friends.

Der Innenarchitekt Dodd Mitchell hat ein altes, aber reizvolles Hotel in ein schönes, intimes Design-Hotel umgewandelt. Das kleine Restaurant und die gemütliche Eingangshalle geben dem Gast das Gefühl, bei Freunden mit gutem Geschmack zu wohnen.

L'architecte d'intérieur Dodd Mitchell a transformé cet hôtel ancien mais charmant en bel hôtel-boutique offrant une ambiance intime en plein centre de Beverly Hills. Le petit restaurant et le foyer, confortables comme une salle de séjour, font sentir que l'on séjourne chez des amis épris de style.

El diseñador Dodd Mitchell transformo un antigũo, pero encantador hotel en un hermoso, intimo "boutique hotel", justo en el centro de Beverly Hills. El pequeño restaurante y cómoda sala del lobby hacen sentir a los huéspedes como si estuvieran quedando con amigos con estilo.

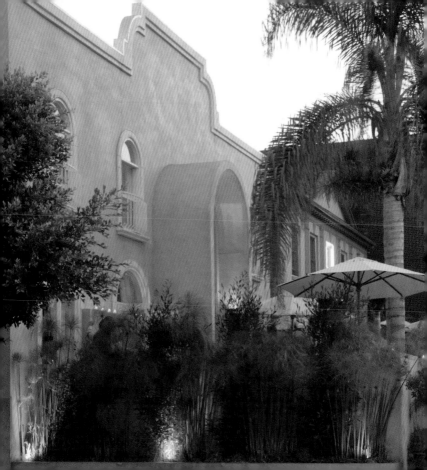

Mosaic Hotel

Don Carridon

2002
125 South Spalding Drive
Beverly Hills

www.mosaichotel.com

The Mosaic is one of the new boutique hotels in Beverly Hills in a quiet residential neighborhood. The design is contemporary with a Mediterranean, Moorish theme. Mosaics and stone details on the floors and walls and a lush pool patio give it an exotic flair.

Das Mosaic ist eines der neuen Design-Hotels in Beverly Hills und liegt in einer ruhigen Wohngegend. Die zeitgemäße Gestaltung hat einen mediterran-maurischen Einschlag. Mosaike und detailreiche Steinarbeiten an Wand und Boden, sowie ein dicht bepflanzter Innenhof mit Pool verleihen dem Hotel ein exotisches Flair.

Le Mosaic est l'un de ces nouveaux hôtels-boutiques dans un quartier résidentiel tranquille de Beverly Hills. Le design y est contemporain avec une note méditerranéenne et mauresque. Des mosaïques et détails de pierre sur les sols et les murs plus un luxueux patio à piscine lui confèrent un certain exotisme.

Mosaic es uno de los "boutique hoteles" más nuevos en Beverly Hills, localizado en un área residencial tranquila. Con diseño contemporáneo y un concepto mediterráneo. Los mosaicos, detalles en las piedras sobre los pisos, paredes y una lujosa piscina en el patio, otorgan un look exótico al hotel.

Raffles L'Ermitage

Chhada Siembieda & Remedios, Inc., Three Architecture

1998
9291 Burton Way
Beverly Hills

www.lermitagehotel.com

Large, uncluttered spaces with natural materials give this hotel an elegant, Zen-like esthetic. The lobby sets the theme with light wood surfaces and antique Chinese textiles on the walls. Olive trees and teak furniture outside continue the theme of understated luxury.

Große, klar gegliederte Räume und natürliche Materialien verleihen diesem Hotel eine elegante Zen-Ästhetik. Die Eingangshalle gibt mit hellen Holzoberflächen und antiken chinesischen Stoffen an den Wänden das Thema vor. Im Außenraum setzen Olivenbäume und Teakmöbel das Thema des Luxus mit feinem Understatement fort.

De grands espaces non agg mérés, délimités par des ma riaux naturels, confèrent à hôtel un style élégant rappela l'esthétique Zen. Le foyer prend ce thème avec des sur ces en bois léger et des texti chinois anciens sur les murs. D oliviers et du mobilier en teck dehors poursuivent à l'extérie le thème du luxe euphémiqu

El uso de materiales naturals y espacios amplios y ordenados crea una estetica elegante de Zen. El vestibulo plantea el concepto con las superficies de madera ligera y antigüos textiles chinos en las paredes. El entendimiento de elegancia surge de igual forma en el exterior con árboles de aceituna y muebles de teca que continuan el concepto planteado de elegancia.

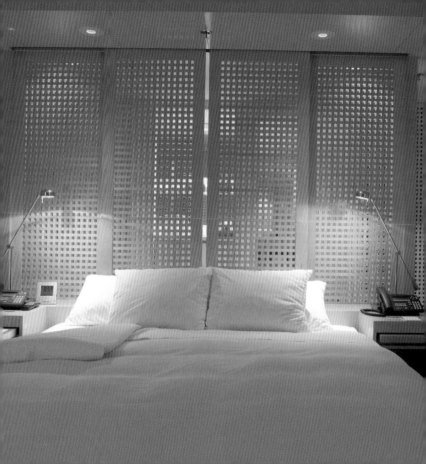

Avalon Hotel

kwid, Kelly Wearstler, Koning Eizenberg Architecture
Nabin Youssef Associates (SE)

2000
9400 West Olympic Boulevard
Beverly Hills

www.avalonbeverlyhills.com
www.kwid.com
www.kearch.com

The Avalon used to be an apartment building; Marilyn Monroe lived here. The glamorous feel of the 60's has been brought back to life with terrazzo floors and stained wood walls. Vintage furniture classics from Charles Eames and George Nelson give it an authentic look.

Das Avalon war vor seiner Renovierung ein Wohngebäude; Marilyn Monroe lebte hier. Der Glamour der 60er Jahre wurde durch Terrazzoböden und dunkle Holzwände wieder heraufbeschworen. Alte Möbelklassiker von Charles Eames und George Nelson verleihen ihm eine authentische Erscheinung.

L'Avalon était à l'origine un immeuble résidentiel ; Marylin Monroe y avait habité. Le glamour des années 60 y a ressuscité avec des sols en terrazzo et des boiseries sombres. Du mobilier classique millésimé, signé Charles Eames et George Nelson, lui confère un cachet d'authenticité.

Un complejo de viviendas en donde Marilyn Moroe vivía se convirtió en el hotel Avalon. Con una apariencia sofisticada de los años 60 resurectada en el espacio con el uso de pisos de terrazzo y paredes de madera pintadas. Muebles antigüos clásicos de Charles Eames y George Nelson le dan estilo autentico.

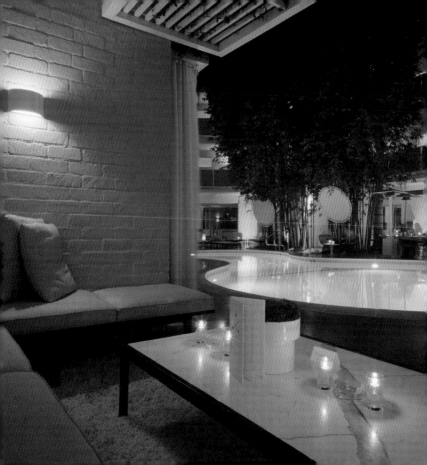

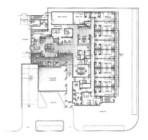

The Ambrose

HLW

2003
1255 20th Street
Santa Monica

www.ambrosehotel.com
www.hlw.com

Los Angeles has hotels in almost any architectural vernacular. What it was missing was an Arts and Crafts hotel. The Ambrose fills this gap and surrounds the guest with the soothing style that combines an English cottage look with Japanese influences.

Los Angeles hat Hotels in beinahe jeder Stilrichtung. Was es noch nicht gab, war ein Arts-and-Crafts-Hotel. Das Ambrose füllt diese Lücke und umgibt den Gast mit einem beruhigenden Ambiente, das den englischen Landhausstil mit japanischen Einflüssen kombiniert.

Les hôtels de Los Angeles exploitent pratiquement tous les registres architecturaux locaux. Ce qu'il manquait était un hôtel des arts et de l'artisanat. L'Ambrose comble cette lacune et enveloppe ses hôtes dans un style apaisant combinant le look cottage anglais avec des influences japonaises.

Los Angeles consta de muchos hoteles de todo tipo de arquitectura vernacular. Carecía solo de un hotel de "Arts and Crafts". Ahora constituido el hotel Ambrose que llena el intervalo y rodea a sus huéspedes con un estilo contemplador combinando el diseño de una casita Inglesa con influencias Japonesas.

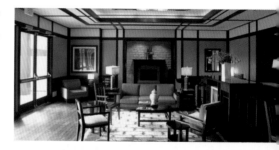

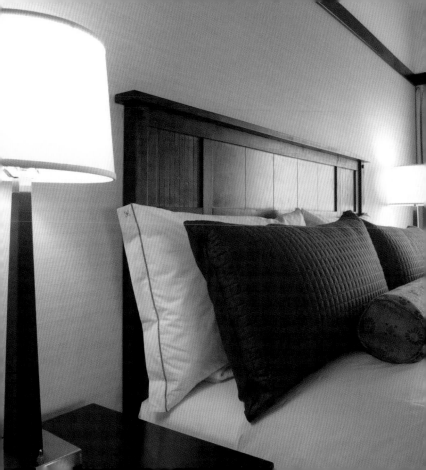

Viceroy

Mia Lehrer, kwid, Kelly Wearstler

2003
1819 Ocean Avenue
Santa Monica

www.viceroysantamonica.com
www.kwid.com
www.mlagreen.com

This is a chance for visitors to observe a new style: "Beverly Regency" at its finest. A 70's hotel has been updated with painted antiques and too many mirrors and it works amazingly well. The regency theme is continued outside with regal poolside tents.

Hier hat der Besucher die Chance einen neuen Stil kennen zu lernen: „Beverly Regency". Ein 70er Jahre-Hotel wurde mit gestrichenen Antiquitäten und zu vielen Spiegeln erneuert, und dies funktioniert erstaunlich gut. Das Regency-Thema setzt sich in den Außenanlagen mit prächtigen Zelten an den Pools fort.

Les visiteurs ont ici la chance d'observer un nouveau style : le style « Régence Beverly » en sa plus fine interprétation. Hôtel des années 70, il a été actualisé avec des antiquités peintes, des miroirs surnuméraires, mais cela fonctionne incroyablement bien. Le thème régence continue à l'extérieur avec des tentes royales en bordure de piscine.

La oportunidad de obeservar un estilo nuevo se presenta ahora con: "Beverly Regency". Hotel de los años 70, reformado con antigüedades pintadas y una cantidad de espejos adaptados perfectamente en el espacio. El concepto continua afuera en las carpas regias de la piscina.

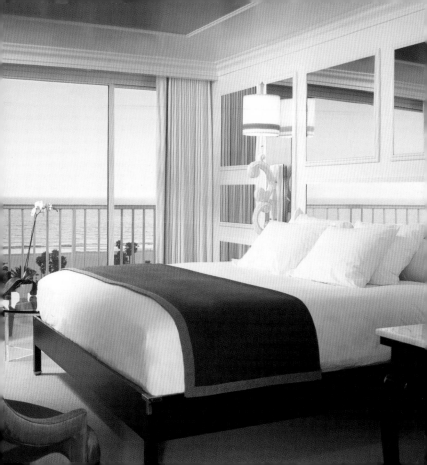

W Westwood

Yabu Pushelberg

1999
930 Hilgard Avenue
Westwood

www.starwood.com

The W hotel is a former apartment building that has been turned into a hip place to stay. The designer worked with what was there and added a stainless steel reception desk, a waterfall entry stair and partition curtains in the lobby to strengthen its 70's appeal.

Das W Hotel ist ein ehemaliges Wohnhaus, das in eine trendige Unterkunft verwandelt wurde. Der Innenarchitekt nutzte die Gegebenheiten und fügte eine Rezeption aus Edelstahl, einen Wasserfall unter der Eingangstreppe und Vorhänge als Raumteiler hinzu, um den 70er Jahre-Charme zu unterstreichen.

Le W Hotel est un ancien immeuble résidentiel transformé en site de séjour hip. L'architecte d'intérieur a travaillé avec ce qui était sur place et a rajouté un comptoir de réception en acier inoxydable, une entrée avec chute d'eau et des rideaux-cloisons dans le foyer pour amplifier l'atmosphère des années 70.

Un antigüo complejo de viviendas se reforma como el hotel W, convertido en el lugar más popular para hospedarse. El diseñador trabajo con lo existente, agregando un escritorio de metal, una fuente en las gradas de entrada, y cortinas de partición en el vestíbulo para intensificar los años 70.

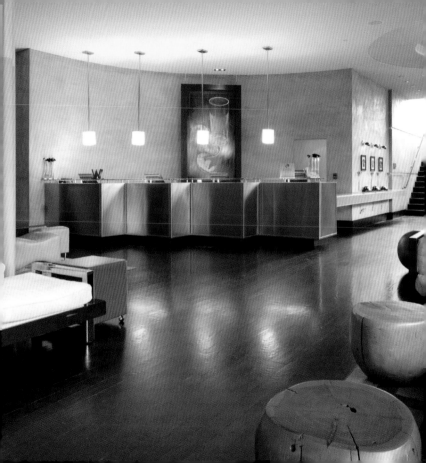

to go . eating
drinking
clubbing
wellness, beauty & sport

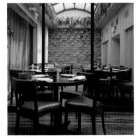

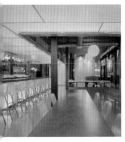
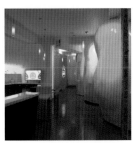
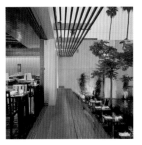
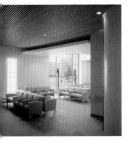
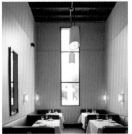
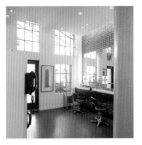

125

Patina
at Walt Disney Concert Hall

Belzberg Architects
Dan Echeto, John A. Martin Associates (SE)

2003
141 South Grand Avenue
Downtown

www.patinagroup.com
www.belzbergarchitects.com

One of the most exciting restaurant interiors right now, Patina is the perfect place to have dinner before curtain time. Curtains became a theme in the design of the space, most exquisitely executed in the milled walnut panels with a rippling curtain effect.

Mit einem der zur Zeit aufregendsten Restaurant-Interieurs ist das Patina der perfekte Ort für ein Abendessen vor einem Konzert. Theatervorhänge wurden zum Gestaltungsthema, am raffiniertesten eingesetzt an einer gewellten Walnusswand, die wie ein geraffter Vorhang wirkt.

A l'heure actuelle, l'un des intérieurs de restaurant les plus intéressant et celui du Patina, l'endroit parfait où aller dîner avant la levée de rideau. Et les rideaux, ici, sont précisément un thème intervenant dans la conception de l'espace. Leur exécution la plus exquise : des panneaux en noyer rappelant les ondulations du rideau.

El interior mejor visto del momento es el de Patina, lugar perfecto para cenar antes de que se baje el telón. Diseño que surge de esta actuación. Mejor visto en la ranura de los paneles de nogal con un efecto de cortinas de ondas.

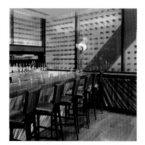

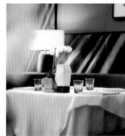

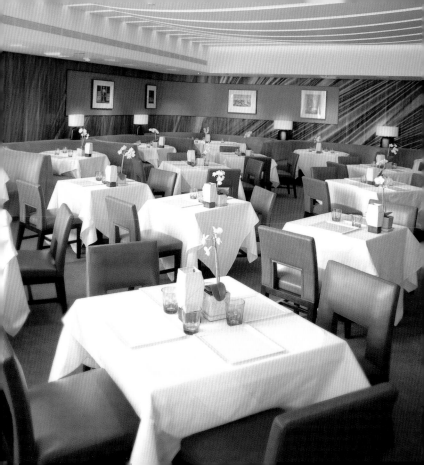

ChoSun Galbee

studio rcl
Paul Franceschi Engineering (SE)

2001
3330 West Olympic Boulevard
Koreatown

www.chosungalbee.com
www.rcl.net

Koreatown has many Korean barbeque places, but none as well designed. The restaurant is entered from the back, through a small garden. Inside, private, basketlike rooms are open to the patio, their walls and ceilings wrapped in bamboo.

In Koreatown gibt es viele Grill-Restaurants, aber keines, das so gut gestaltet ist wie dieses. Man betritt das Restaurant von der Rückseite durch einen Garten. Im Innern sitzt man in korbartigen Privatzimmern, die sich zum Hof öffnen; ihre Wände und Decken sind mit Bambusholz verkleidet.

Koreatown comporte plusieurs sites à barbecues coréens, mais aucun aussi bien conçu. On entre dans le restaurant par l'arrière, en traversant un petit jardin. A l'intérieur, de petites pièces privées en forme de paniers s'ouvrent sur le patio ; leurs murs et leurs plafonds sont enveloppés dans du bambou.

Koreatown tiene muchos lugares para comer barbeque, pero ninguno también diseñado. La entrada al restaurante es por la parte posterior al cruzar un pequeño jardín; los cuartos de este lugar fueron diseñados en forma de canasta, convirtiéndose en espacios privados abriéndose al patio. Sus paredes y techos están envueltos en bambú.

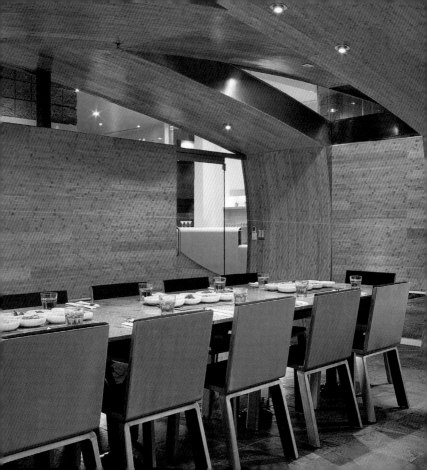

Pho Café

Escher GuneWardena

2002
2841 West Sunset Boulevard
Silverlake

www.egarch.net

Here the minimalism of a sparse, low-key restaurant has been crossed with an intentional, elegant simplicity. This Vietnamese restaurant serves only Pho, a popular noodle soup, so the straightforward note is reflected in the décor and the menu.

Hier wurde der Minimalismus eines kargen einfachen Restaurants mit einer bewusst eingesetzten eleganten Schlichtheit gekreuzt. In diesem vietnamesischen Restaurant gibt es nur Pho, eine beliebte Nudelsuppe, also spiegelt sich diese Einschränkung in der Innenausstattung und der Speisekarte wider.

Ici, le minimalisme d'un resta rant discret et peu enclin à l'o nement a été croisé avec u simplicité intentionnellement é gante. Ce restaurant vietnami ne sert que du Pho, soupe de p tes populaires, faisant que ce atmosphère franche se reflè dans le décor et dans le men

Este escaso espacio minimalista, no muy conocido fue intencionalmente diseñado de forma simple y elegante. Es un restaurante vietnamés que solo sirve Pho, una sopa de nudos muy popular, anunciado directamente en el menú y la decoración.

Ammo

Graft Architects

2000
1155 North Highland Avenue
West Hollywood

www.ammocafe.com
www.graftlab.com

Working with a low budget, the architects managed to turn this small space with a high ceiling into a restaurant that reflects the concept of the menu. The shaker-like, light wood interior is a good background for the healthy, organic food the restaurant is known for.

Trotz eines kleinen Budgets ist es den Architekten gelungen, einen kleinen Raum mit hoher Decke in ein Restaurant zu verwandeln, das zum Menü-Konzept passt. Das helle Holz-Interieur im Shaker-Stil gibt einen guten Hintergrund für das gesunde Bio-Essen ab, für welches das Restaurant bekannt ist.

Ne disposant que d'un budget réduit, les architectes ont réussi à transformer ce petit espace à haut plafond en un restaurant qui reflète bien le concept de son menu : l'intérieur en bois au style des Shaker crée l'environnement adéquat à la nourriture saine et organique sur laquelle ce restaurant a bâti sa réputation.

Con un proyecto de bajo presupuesto, los arquitectos encontraron la manera de transformar este pequeño espacio de alta elevación, en un restaurante que refleja el concepto del menú. Típico del estilo "shaker", el uso de madera clara en el interior es un buen fondo para la saludable y comida organica por la cual el restaurante es conocido.

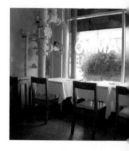

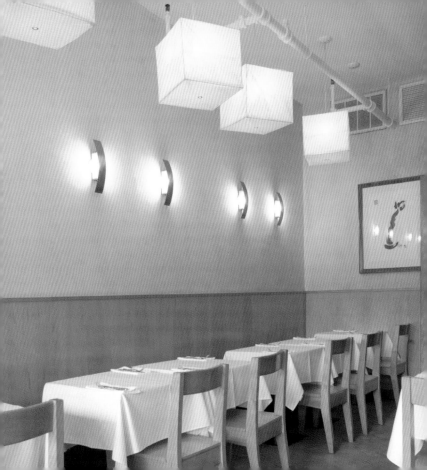

A.O.C.

Donald Randall, Barbara Barry, Inc.

2002
8022 West Third Street /
Crescent Heights Blvd
West Hollywood

www.aocwinebar.com
www.barbarabarry.com

This wine bar and restaurant has an emphasis on wine tasting. The bar serves 50 wines by the glass and the menu is perfect to accompany them. The bar is the focal point of the room and the paneled walls are lined with wine racks.

Diese Weinbar mit Restaurant ist auf Weinproben spezialisiert. Die Bar hat 50 offene Weine im Angebot und die Speisenauswahl bringt diese perfekt zur Geltung. Der Tresen ist der Mittelpunkt des Raumes und die holzverkleideten Wände werden von Weinregalen gesäumt.

Ce bistrot restaurant a mis l'accent sur le taste-vin. Son bar sert au verre 50 vins différents et un menu qui les accompagne parfaitement. Le bar constitue le point de convergence de la salle et les panneaux muraux sont garnis de porte-bouteilles.

Este es un bar y restaurante especialmente para probar vinos. Donde sirven 50 diferentes tipo de vino los cuales son vendidos por copa solamente, acompañados por un menú perfecto. La barra se convierte entonces en el punto de enfoque del lugar y las paredes se alinean con los botelleros de vino.

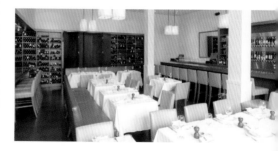

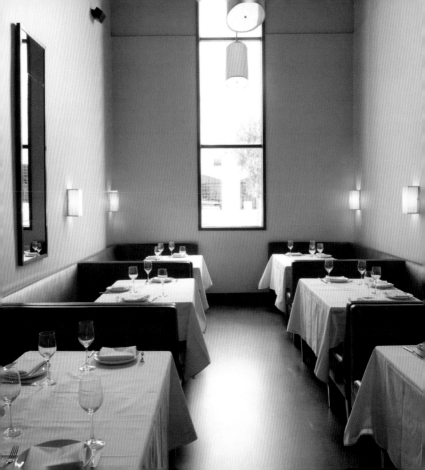

Falcon

John Friedman Alice Kimm Architects, Inc., Dodd Mitchell Design
Andrew Chan (SE)

2002
7213 Sunset Boulevard
West Hollywood

www.falconslair.com
www.doddmitchell.com

This is a clever remodel of an old craftsman-style house that took it into a very different direction. The interior is dark and intense, the exterior patio light and sparse with bleacher seating and open fireplaces.

Dies ist eine intelligente Renovierung eines alten Wohnhauses im Craftsman-Stil, die es vollkommen veränderte. Die Innenräume sind dunkel und entfalten eine intensive Wirkung, die Terrasse ist hell und karg, mit Bänken und offenen Kaminen.

Intelligente remise en état d'u vieille maison de style artisana qui emprunte maintenant une rection très différente. L'intérie est sombre et intense, le pa extérieur léger et sobre avec o sièges en gradin et des cher nées.

Esta es una astuta remodelación de una casa antígua con estilo artesanal que surgió de una forma muy diferente. El espacio interior es intenso y oscuro con un patio exterior iluminado, bancas dispersas y chimeneas abiertas.

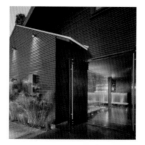

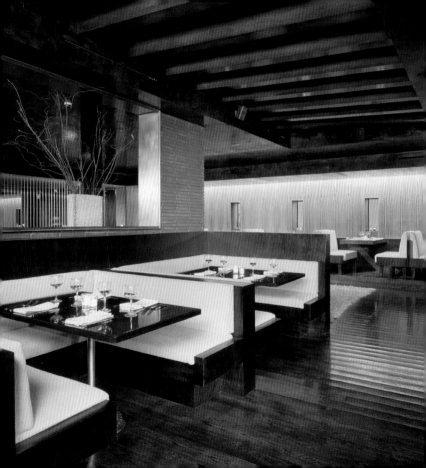

Grace

Michael Berman Limited

2003
7360 Beverly Boulevard
West Hollywood

www.gracerestaurant.com
www.michaelbermanlimited.com

Of all the new restaurants, this was recently voted to be the most beautiful one. The contrast between the dark wood beams and paneling and the soft, neutral colors gives it a modern and elegant feeling.

Von allen neuen Restaurants wurde dieses kürzlich zum schönsten gewählt. Der Kontrast zwischen den dunklen Holzbalken und -paneelen und den weichen, neutralen Farben gibt ihm eine moderne und elegante Atmosphäre.

De tous les nouveaux restaurants, un suffrage l'a récemment élu le plus beau. Le contraste entre ses obscurs panneaux et poutres en bois d'une part, les couleurs douces et neutres d'autre part, lui confère une ambiance moderne et élégante.

De todos los restaurantes nuevos de la ciudad, este ha sido recientemente considerado uno de los mas lindos. Presentando su modernidad y elegancia con el contraste entre la estructura de madera obscura, los paneles, y los colores neutrales usados en el espacio.

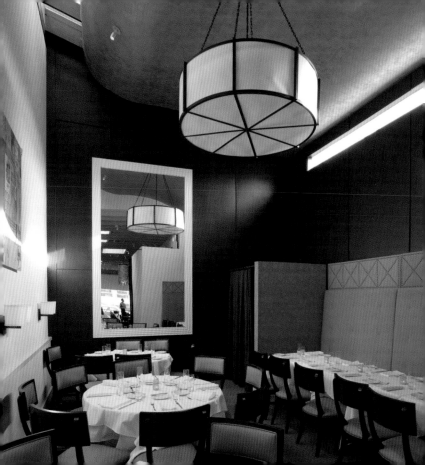

Koi

Thomas Schoos Design

2002
730 North La Cienega Boulevard
West Hollywood

www.koirestaurant.com
www.schoos.com

Koi was designed according to the teachings of Feng Shui. The four dining areas are decorated in colors to evoke the four elements of nature, water, fire, air and light. The sound of running water, open fireplaces and the light of votive candles complete the serene atmosphere.

Das Koi wurde nach den Regeln von Feng Shui entworfen. Die vier Speisezimmer sind in Farben gestaltet, welche die vier Elemente Wasser, Feuer, Luft und Licht repräsentieren sollen. Offene Kamine, Kerzenlicht und der Klang plätschernden Wassers runden die ruhige Atmosphäre ab.

Le Koi a été conçu selon les enseignements du Feng Shui. Les quatre espaces de restauration ont été décorés dans des teintes évoquant les quatre éléments de la nature : l'eau, le feu, l'air et la lumière. Le bruissement de l'eau qui s'écoule, des cheminées et la lumière de bougies votives parfont la sérénité de son atmosphère.

Koi fue diseñado basado en las enseñanzas de Feng Shui. Es así como surgen las cuatro diferentes áreas para comer, decoradas de colores reflejando los cuatro elementos de la naturaleza, agua, fuego, aire y luz. Para completar este ambiente tan sereno, el sonido del agua destilándose, chimeneas al aire libre y la iluminación de las velas son aplicados en el espacio.

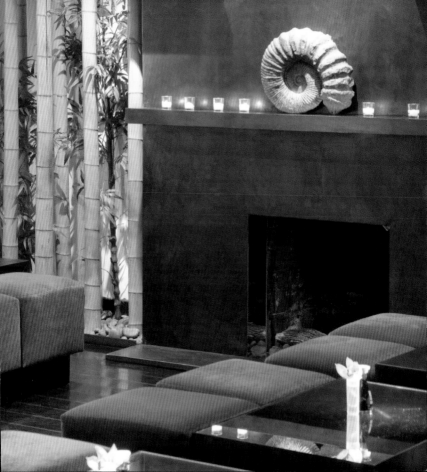

Cinch

Dodd Mitchell Design

2003
1519 Wilshire Boulevard
Santa Monica

www.cinchrestaurant.com
www.doddmitchell.com

This is an utterly fun yet elegant restaurant that was inspired by the lounge architecture of the 60's. Many different textures and surfaces on the walls and ceiling carry the theme throughout the space. The dining room is grown-up and serious with a psychedelic twist.

Dieses sehr homorvolle und gleichzeitig elegante Restaurant ist von der Lounge-Architektur der 60er Jahre inspiriert. Die verschiedenen Texturen und Oberflächen der Wände sind `ein raumbestimmendes Thema. Der Speisesaal wirkt seriös mit leicht psychedelischem Einschlag.

Voici un restaurant on ne pe plus distrayant et en mêm temps élégant, inspiré par l'a chitecture du séjour dans les a nées 60. De nombreuses text res et surfaces différentes sur le murs et le plafond véhiculent c thème dans tout l'espace Cinc La salle à manger a grandi et pr un air sérieux tempéré par ur dérive psychédélique.

Este es un restaurante absolutamente divertido y elegante, inspirado por la arquitectura lounge de los años 60. Mucha de las texturas, diferentes superficies en las paredes y el techo llevan este concepto atravez del espacio. El comedor ha sido ampliado seriamente con una vuelta psicodélica.

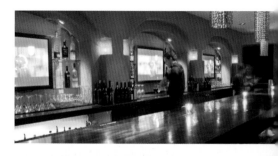

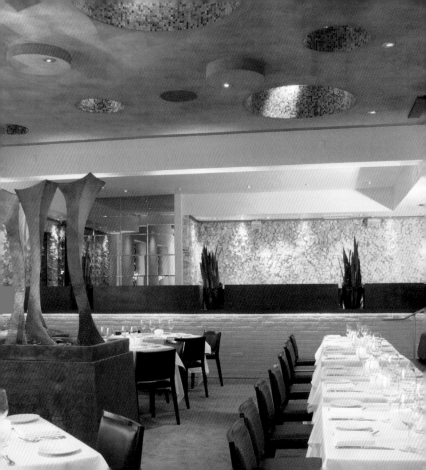

The Brig

John Friedman Alice Kimm Architects, Inc.
William Koh and Associates (SE)

2001
1515 Abbot Kinney Boulevard
Venice

www.jfak.net

The building used to house a bar owned by a boxer that had a cult following in Venice. The architects wanted to keep some of the aspects of the old bar alive with materials that could have been in the old space: terrazzo flooring and a mahogany bar counter.

Das Gebäude beherbergte früher eine in Venice beliebte Bar, die einem Boxer gehörte. Die Architekten wollten mit Materialien, die auch zu der früheren Lokalität hätten gehören können, etwas vom Flair der alten Bar erhalten: Terrazzoboden und eine dunkle Mahagoni-Theke.

Ce bâtiment hébergeait un bar possédé par un boxeur qui allait devenir culte à Venice. Les architectes voulaient maintenir vivants certains aspects de l'ancien bar, avec des matériaux qui auraient été susceptibles de s'y trouver : un sol en terrazzo et un comptoir de bar en acajou.

Este edificio que alojaba un bar de un boxeador tenía una tradición a seguir en la ciudad de Venice. Para mantener vivo alguno de los aspectos del antiguo bar, los arquitectos optaron por mantener materiales usados en este espacio como: el piso terrazzo y la barra de caoba.

144

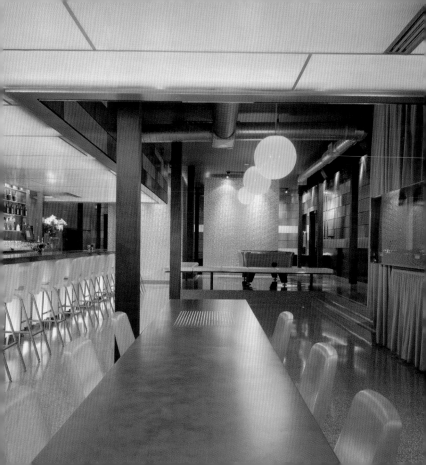

Saladang Song

Tolkin & Associates Architecture
Kurily Szmanski Tchirkow, Inc. (SE)

2000
383 South Fair Oaks Avenue
Pasadena

www.tolkinarchitecture.com

The restaurant, a freestanding building, is surrounded by tilt-up concrete slabs and laser-cut steel screens. This outer wall forms a patio and also shields the interior from the busy street. The owner's apartment sits on top of the restaurant.

Das Restaurant, ein freistehendes Gebäude, ist von übereinandergestapelten Betonplatten und lasergeschnittenen Stahlgittern umgeben. Diese Wand bildet einen Hof und schützt gleichzeitig den Innenraum vor dem Lärm der Straße. Die Wohnung der Inhaberin liegt über dem Restaurant.

Ce restaurant, édifice sans voisin immédiat, est entouré de dalles en béton posées sur chant et de cribles en acier découpés au laser. Ce mur extérieur forme un patio et protège aussi l'intérieur contre l'agitation de la rue. L'appartement du propriétaire se trouve au-dessus du restaurant.

Este restaurante independiente de sus alrededores, esta rodeado de paredes inclinadas de hormigón y células de acero cortadas por medio de láser. Estas paredes exteriores forman el patio y protegen el interior de la calle tan transitada. Asentado sobre este restaurante, se encuentra el apartamento del propietario.

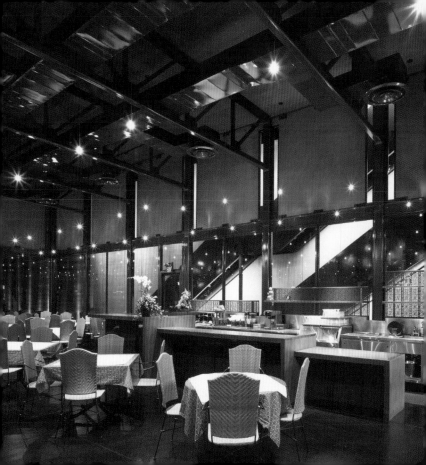

Electric Sun 3

Escher GuneWardena
Mahdi Aluzri (SE)

2003
8471 Beverly Boulevard
Los Angeles

www.wetanla.com
www.egarch.net

This is the third tanning salon the architects have worked on in collaboration with artist Jonathan Williams. The individual tanning booths are wrapped in translucent acrylic and become colorful lanterns when they are lighted from the inside.

Dies ist das dritte Sonnenstudio, das die Architekten mit dem Künstler Jonathan Williams zusammen ausgestaltet haben. Die einzelnen Kabinen sind mit transluzenten Acrylscheiben eingefasst und verwandeln sich in farbenfrohe Laternen, wenn sie von innen beluchtet werden.

Voici le troisième salon de bronzage sur lequel les architectes ont travaillé en collaboration avec l'artiste Jonathan Williams. Les cabines de bronzage individuelles sont enveloppées dans une matière acrylique translucide et deviennent des lanternes colorées une fois éclairées de l'intérieur.

Con la colaboración del artista Jonathan Williams, los arquitectos han diseñado su tercer salón de bronceados. Los cubículos individuales de bronceados se encuentran envueltos en un acrílico transparente que se convierten en linternas coloridas cuando son iluminadas por el interior.

Orthopaedic Hospital L.A.

R.L. Binder, FAIA Architecture & Planning
Brondow & Johnston Associates (SE)

2003
2501 South Hope Street
Los Angeles

www.binderarchitects.com
www.orthohospital.org

The surrounding campus was built in the 1960's and has a clean, horizontal modern look. The new orthopaedic hospital is a reinterpretation of that style but in a more contemporary fashion. The horizontal lines of the facade and sunscreens repeat the lines of neighboring buildings.

Der umgebende Campus wurde in den 60er Jahren erbaut und hat ein klares, modernes, horizontal ausgerichtetes Erscheinungsbild. Die neue orthopädische Klinik ist eine etwas zeitgemäßere Neuinterpretation dieses Stils. Die horizontalen Linien der Nachbargebäude werden in der Fassade und in den Sonnenschutzvordächern wiederholt.

Son campus périmétrique a été construit dans les années 60 et il présente un look net, horizontal, moderne. Le nouvel hôpital orthopédique réinterprète ce style mais de façon plus contemporaine. Les lignes horizontales de la façade et les pare-soleil reprennent les lignes des bâtiments voisins.

Construido en los años de 1960 comprometido totalmente con la época moderna. El nuevo hospital ortopédico es una reinterpretación de sus alrededores, pero en una forma más contemporánea. Con su rejilla de acero en la fachada remite a las edificaciones de su alrededor.

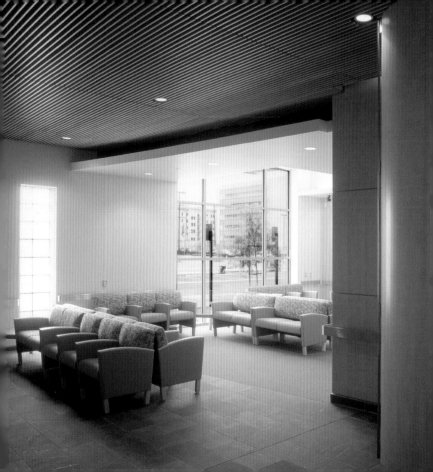

ona spa

ROC

1999
7373 Beverly Boulevard
Los Angeles

www.onaspa.com

The ona spa is located in a historical building that used to be a famous restaurant called the "Spanish Kitchen". Long abandoned and haunted, only the shell of the building and the sign remained. Now the building has found a new tenant, who cleverly kept the sign that now reads only "Spa".

Der ona spa befindet sich in einem historischen Gebäude, das einmal ein bekanntes Restaurant namens „Spanish Kitchen" war. Nach langem Leerstand und angeblichem Spuk blieben nur die Außenwände und ein großes Schild erhalten. Nun hat das Haus einen neuen Besitzer, der gewitzterweise das Schild behielt, auf dem jetzt nur noch „Spa" zu lesen ist.

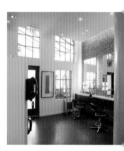

L'ona spa est situé dans un bâtiment historique, synonyme d'un restaurant fameux appelé la « Spanish Kitchen ». Longtemps abandonné et hanté, n'en étaient restées que la carcasse et l'enseigne. Maintenant, le bâtiment a trouvé un nouveau locataire qui, intelligemment, a supprimé « nish » et « Kitchen » pour ne conserver que le « Spa ».

El ona spa esta localizado en un edificio histórico que solía ser un restaurante famoso llamado "Spanish Kitchen". En donde solo quedo el exterior del edificio y el letrero de este. Este edificio abandonado y embrujado, encontró un propietario quien ingeniosamente mantuvo el letrero que ahora solo lee "Spa".

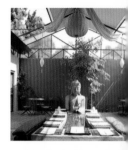

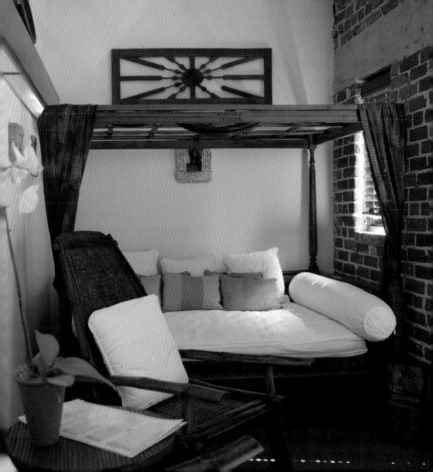

Kinara Spa

Belzberg Architects
Janah Risha Engineers (SE)

2002
656 North Robertson Boulevard
Beverly Hills

www.kinaraspa.com
www.belzbergarchitects.com

This is the ideal spa to spend a whole day relaxing. The aesthetic details of the interior will do as much for you as the massage. Frosted glass with bamboo leaves, exotic woods and natural light in all the treatment rooms will calm your senses.

Dies ist der perfekte Spa, um einen ganzen Tag dort zu verbringen und zu entspannen. Die schönen Details der Innenraumgestaltung tun einem genauso gut wie die Massagen. Sandgestrahlte Glasscheiben mit Bambusblättern, exotische Hölzer und Tageslicht in allen Räumen beruhigen die Sinne.

La mini-station balnéaire idéale pour passer une journée de relaxation complète. Les détails esthétiques de son intérieur vous feront autant de bien que la séance de massage. Du verre dépoli avec des feuilles de bambou, des bois exotiques et l'éclairage naturel dans toutes les salles de traitement sont là pour calmer vos sens.

Este es un spa ideal para relajarse todo un día, donde los detalles estéticos del interior actúan de la misma manera que el masaje. El uso de vidrio ahumado con hojas de bambú, maderas exóticas y luz natural en los cuartos de tratamiento ayudan a calmar todos tus sentidos.

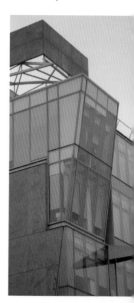

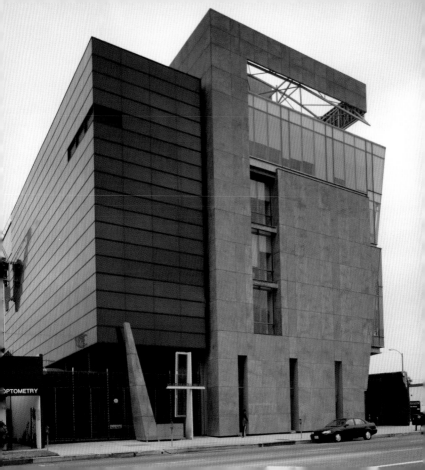

Fred Segal Beauty

m Architects

2002
500 Broadway
Los Angeles

www.fredsegalbeauty.com
www.marchstudio.com

The Fred Segal salon and spa is known to be on the cutting edge of fashion. The new interior reflects that. Clean surfaces and structures give it an architectural statement and at the same time allow for the stylist's individuality.

Der Fred Segal Salon and Spa ist für seine avantgardistische Mode bekannt. Das neue Interieur spiegelt dies wider. Blanke Oberflächen und Strukturen verleihen ihm eine architektonische Aussage und geben gleichzeitig den einzelnen Stylisten die Möglichkeit, sich individuell hervorzuheben,

Le salon et spa Fred Segal e connu pour exprimer le tout de nier cri de la mode. Le nouvel in térieur le reflète bien. Des surfa ces et structures propres l confèrent une expression arch tecturale tout en faisant resso tir en même temps l'individua té de ce styliste.

El salón de Fred Segal es reconocido como uno de los espacios de última moda. Lo cual es reflejado ahora en día en el nuevo interior de este espacio. El interior esta conformado generosamente y su estructura lo reflejan al igual. De la misma manera reconociendo la individualidad del estilista.

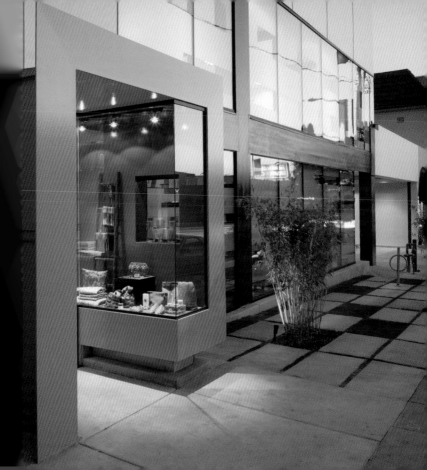

Dermalogica

Abramson Teiger Architects
Sigma Design Structural Engineers (SE)

2003
1022 Montana Avenue
Santa Monica

www.dermalogica.com
www.abramsonteiger.com

To explore the elasticity of skin, the architects created womb-like pods as treatment rooms. These pods become their own little buildings on sunny days, when the spa opens its front facade and lets the ocean breeze flow in.

Diesem Spa, der sich darauf spezialisiert die Elastizität der Haut zu verbessern, gaben die Architekten höhlenartige Schalen als Behandlungszimmer. An sonnigen Tagen, wenn der Spa seine vordere Fassade öffnet und die Meeresbriese herein lässt, werden diese Räume zu eigenen kleinen Gebäuden.

Pour explorer l'élasticité de la peau, les architectes ont créé des espaces en nids d'abeilles officiant de salles de traitement. Ces espaces deviennent de véritables petits bâtiments par beau temps, lorsque le spa ouvre sa façade frontale pour que le baigne la brise océane.

Explorando la elasticidad de la piel, los arquitectos crearon cuartos de tratamiento en forma de contenedores de vientre. Estos contenedores tienen la elasticidad suficiente para convertirse en identidades independientes, en donde el spa abre su fachada frontal dejando la brisa del océano fluir en el espacio en días soleados.

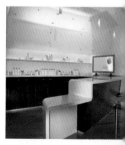

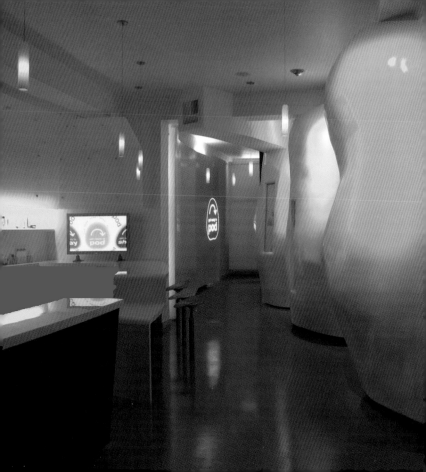

to shop . mall
 retail
 showrooms

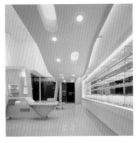
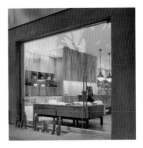

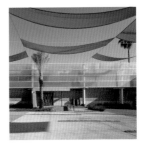
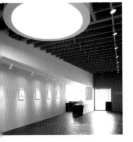

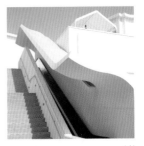

Chan Luu

Marmol Radziner & Associates

2003
112 South Robertson Boulevard
West Hollywood

www.fragments.com
www.marmolradziner.com

A jewelry store can either compete with its wares or showcase them. Chan Luu does the latter by creating a subtle and natural background for the delicate accessories they sell. The materials for the custom-designed cabinetry and wall treatments are sandblasted birch and blackened steel.

Ein Juwelierladen kann sich entweder durch sein Angebot oder die Art der Präsentation von der Konkurenz absetzen. Chan Luu tut letzteres, indem eine subtile und natürliche Umgebung für den raffinierten Schmuck geboten wird, der hier verkauft wird. Die Materialien für Vitrinen und Wandverkleidung sind sandgestrahltes Birkenholz und schwarzer Stahl.

Une bijouterie entre en compétition avec ses produits ou les confine en vitrines. Chan Luu a choisi la vitrine, en créant un arrière plan subtil et naturel pour mettre en valeur les accessoires délicats proposés à la vente. Les matériaux formant ces volumes d'exposition sur mesure et les décorations murales sont en bouleau passé au jet de sable.

Una joyería puede competir con su mercancía o solo exhibirla. Chan Luu creo un nuevo estilo de exhibir sus joyas; creando un fondo natural para los delicados accesorios de venta. Los materiales usados aquí fueron diseñados especialmente para este espacio; los gabinetes y tratados de pared fueron diseñados de madera de abedul con un chorro de arena y acero negro.

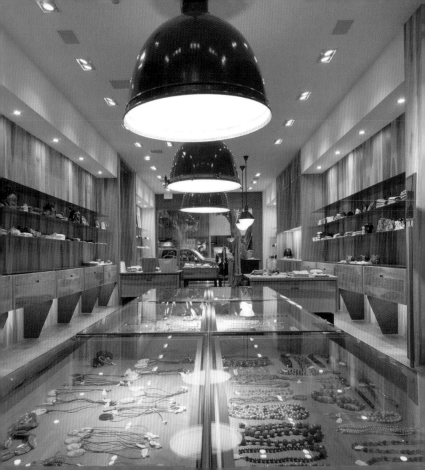

Costume National

Marmol Radziner & Associates

1999
8001 Melrose Avenue
West Hollywood

www.costumenational.com
www.marmolradziner.com

Situated on a corner of Melrose Avenue, the Costume National Store gets a lot of natural light and exposure. The store itself is the showcase, no display needed. White lacquer wall panels and Lucite shelves reflect the minimal style of the collection.

Der Costume National Store steht auf einem Eckgrundstück der Melrose Avenue und bekommt dadurch viel Sonnenlicht und eine erhöhte Präsenz an der Straße. Der Laden ist Blickfang genug, man braucht keine Schaufenster. Weiß lackierte Wandpaneele und Lucite-Regale spiegeln den Minimalismus der Kollektion wider.

Situé au coin de l'Avenue Melrose, le magasin Costume National Store s' éclaire largement à la lumière naturelle, à laquelle il est d'ailleurs très exposé. Le magasin lui-même est la vitrine, il n'a besoin d'aucun présentoir. Les murs laqués de blanc et les rayonnages en Lucite reflètent le style minimaliste de la collection.

Debido a su ubicación de Costume National Store, se expone y recibe luz natural; localizado en la esquina de Melrose Avenue. La tienda en si es la vitrina, sin la necesidad de otra. Paneles de pared lacquer y repisas Lucite reflejan el estilo minimalista de esta colección.

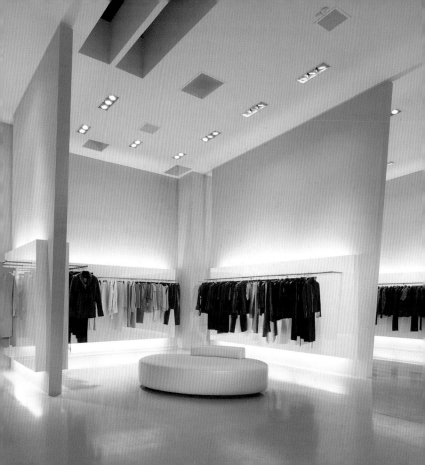

Trina Turk Boutique

kwid, Kelly Wearstler

2003
8008 West Third Street
West Hollywood

www.trinaturk.com
www.kwid.com

Third Street is quickly turning into one of the most popular shopping streets in the city. The Trina Turk store is one of its most recent additions. The playful, ironic interior works perfectly with the colorful yet unfussy clothes for both men and women.

Die Third Street entwickelt sich in rasantem Tempo zu einer der beliebtesten Einkaufsstraßen der Stadt. Der Trina Turk-Laden ist eines der neuesten Geschäfte hier. Die spielerische, ironische Innenraumgestaltung ist wie maßgeschneidert für die farbenfrohe, aber gleichzeitig schlichte Damen- und Herrenmode.

Third Street est rapidement en train de se transformer en l'une des rues les plus commerçantes de la ville. Le magasin Trina Turk est l'un des plus récents venu l'agrémenter. Son intérieur à la fois ludique et ironique donne parfaitement la réplique à l'habillement coloré mais sans manières, tant masculin que féminin.

La Third Street ha sido rápidamente convertida en una de las calles de compra más populares de la ciudad. Con una de sus mas recientes adiciones, Trina Turk store en donde el interior esta configurado irónicamente reflejando el colorido tipo de ropa de venta aquí para hombre y mujer.

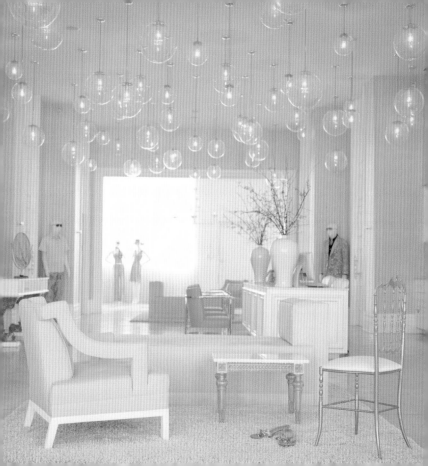

I.a. Eyeworks

Neil M. Denari Architects Inc.
Gordon Polon Engineering (SE)

2002
7386 Beverly Boulevard
Mid Wilshire

www.iaeyeworks.com
www.nmda-inc.com

For its new store, the clients wanted an environment that existed outside of the fashions of architecture. What they got was a store where a continuous flowing surface forms the elements of ceiling, bench, display and counter with movable furniture elements.

Für ihr neues Geschäft wünschten sich die Besitzer ein Verkaufsumfeld, das keiner modischen Architektur entspricht. Was sie bekamen, ist ein Laden, in dem Flächen, Decke, Bank, Regale und Theke mit beweglichen Möbelelementen eine Einheit bilden.

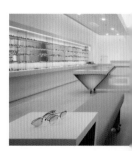

Pour leur nouveau magasin, les clients voulaient un environnement hors des modes architecturales. Ce qu'ils ont obtenu est un ouvrage où une surface continue et fluide forme les éléments du plafond, du banc, du présentoir et du comptoir avec des éléments de mobilier nomades.

Para esta tienda los clientes deseaban un ambiente fuera de lo común de arquitectura. Proyecto realizado, en el cual el techo, una banca, vitrina y barra con muebles movibles fluyen sobre la superficie en forman continua.

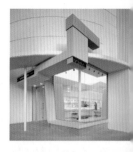

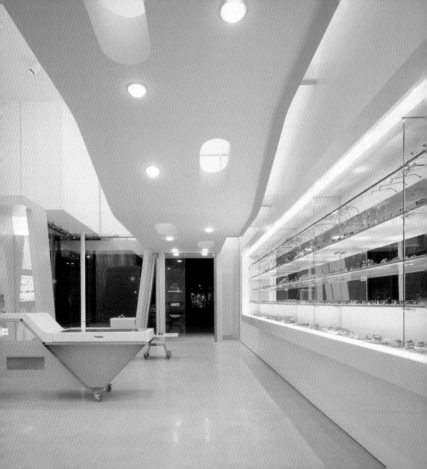

Noodle Stories

John Friedman Alice Kimm Architects, Inc.

1998
8323 West Third Street
Mid Wilshire

www.jfak.net

The owner hired the architects to combine two existing stores into one. The central beam and columns give the store its symmetrical layout and opens it up to the back of the space for a very casual and personal atmosphere including a kitchen and a ping-pong table.

Die Besitzerin engagierte die Architekten, um zwei bestehende Läden zu einem zusammenzufügen. Der Mittelbalken und Säulen machen den Laden symmetrisch und öffnen ihn zum hinteren Teil des Raums, wo eine Küche und eine Tischtennisplatte eine ungezwungene persönliche Atmosphäre schaffen.

Le propriétaire a chargé les architectes de synthétiser deux magasins préexistants en un seul. La poutre et la colonne centrales confèrent au magasin un agencement symétrique et l'ouvrent vers l'arrière de l'espace, pour créer une atmosphère très détendue et personnelle comprenant une cuisine et une table de ping-pong.

Dos tiendas existentes combinadas para formar una, constituyen este proyecto, diseñadas por el propietario y realizado por los arquitectos contratados por el mismo. Las columnas centrales estructuran la fachada simétrica de la tienda, ampliándola hasta la parte posterior del espacio creando un ambiente causal y personal que incluyen una cocina y una mesa de ping-pong.

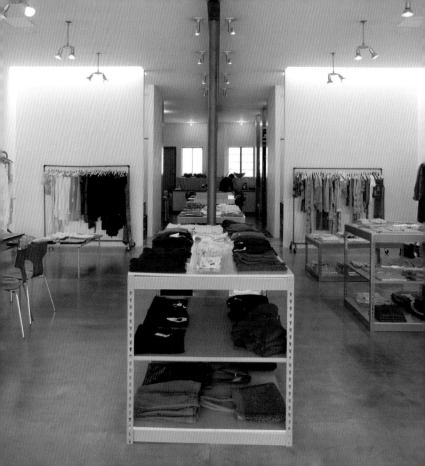

Works on Paper

Corsini Architects
Dean Hussein (SE)

2000
6150 Wilshire Boulevard
Mid Wilshire

www.corsiniarchitects.com

The works featured in this art gallery represent the entry-level art market: art that will be displayed in homes. The gallery owner wanted the walls to be suited to different scales of art and to create an intimate space that would not overwhelm smaller art objects.

Die Kunst, die in dieser Galerie gezeigt wird, ist Einstiegskunst: Objekte die später in Privathäusern ausgestellt werden. Die Galeristin wollte, dass die Wände für unterschiedlich große Kunstwerke geeignet sind, die Galerie aber trotzdem intim genug ist, um kleinere Kunstobjekte nicht zu erdrücken.

Les travaux exposés dans ce galerie d'art représentent le m ché de l'art au niveau découv te. Cet art sera exposé aux c miciles de ses nouveaux p priétaires. Celui de la galerie v lait que les murs soient adap à différentes échelles d'art créer un espace intimiste n'écrase point pas les objets d de plus petite taille.

El trabajo presentado aquí representa el nivel de entrada del mercado de arte: arte exhibida en casas. El propietario de esta galeria queria que las paredes de esta galería fueran creadas de distintos tamaños para acomodar las diferentes escalas de arte, formando un espacio íntimo que alojara otros objetos de arte de escala menor al igual.

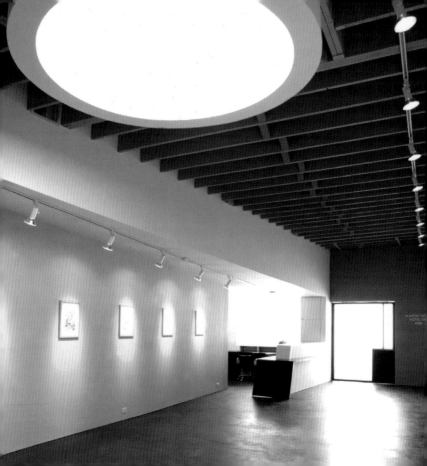

Hennessey + Ingalls

Architecture Bookstore

Marmol Radziner & Associates

2003
214 Wilshire Boulevard
Santa Monica

www.hennesseyingalls.com
www.marmolradziner.com

When this bookstore for architecture, art and design moved, it commissioned Marmol and Radziner for their new space. A new wood and concrete "box" was inserted into the existing shell, exposing the outer "box" at intervals at the ceiling and the floor.

Als dieser Architektur- und Kunst- und Designbuchladen umzog, beauftragten die Inhaber Marmol und Radziner, ihren neuen Laden zu entwerfen. Eine neue „Schachtel" aus Holz und Beton wurde in das bestehende Gehäuse implantiert und gewährt durch Decke und Boden immer wieder Durchblicke auf die äußere „Schachtel".

Lorsque cette librairie d'architecture, d'art et de design a déménagé, elle a chargé Marmol Radziner d'aménager son nouvel espace. Une nouvelle « boîte » en bois et en béton a été insérée dans la « coque » existante, avec pour effet d'exposer à intervalle la « boîte » extérieure au niveau du plafond et du plancher.

Al momento que la librería cambia su ubicación, el proyecto fue comisionado a los arquitectos Marmol y Radziner. Donde una "caja" compuesta de hormigón y madera fue integrada en un edificio ya existente, exponiendo la "caja" exterior a ciertos puntos en el techo y piso.

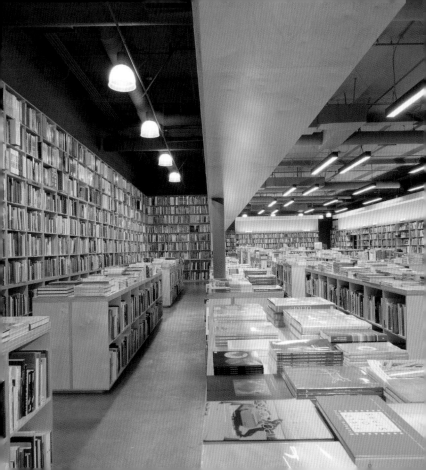

Shops on Lake Avenue

MDA Johnson Favaro
Novi Uce (SE)

2003
South Lake Avenue
Pasadena

www.marmolradziner.com

Three new buildings were designed around a classic 50's department store. While the existing store was meant for a suburban setting with separate parking and closed to the street, the new shops open directly onto the sidewalk for a more urban character.

Drei neue Gebäude wurden um ein klassisches Kaufhaus der 50er Jahre gebaut. Während das frühere Kaufhaus mit separater Parkgarage geschlossener Straßenfront für ein vorstädtisches Umfeld gedacht war, öffnen sich die neuen Läden direkt zur Straße, um für einen eher innerstädtischen Charakter zu sorgen.

Trois nouveaux bâtiments ont é construits autour d'un grand m gasin dans le style classique d années 50. Tandis que lui, cor pour un environnement banlie sard, possédait son propre pa king et n'ouvrait pas sur la r les nouvelles boutiques donne directement sur le trottoir p conférer au lieu un caractère p urbain.

Alrededor de un departamento clásico de tiendas de los anos 50, surgieron tres edificios nuevos. En donde las antiguas tiendas fueron diseñadas para un área suburbia con estacionamiento separado y lejos de la calle; las tiendas nuevas se abren directamente con un carácter más urbano.

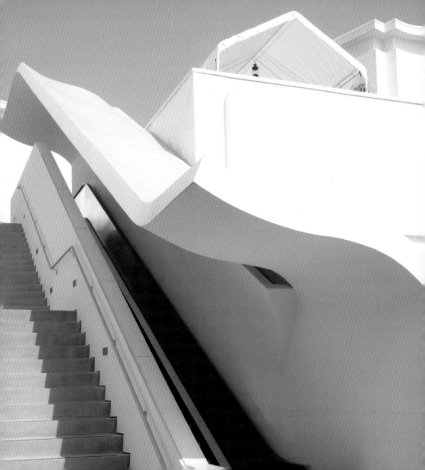

Los Angeles
Design Center

John Friedman Alice Kimm Architects, Inc.
Mackintosh & Mackintosh (SE)

2004
5955 South Western Avenue
South Central

www.jfak.net

The Design Center sees itself as an alternative to the Pacific Design Center, giving furniture designers the exposure they need. The existing brick building was upgraded using light and transparent materials to establish its design content but still preserving its warehouse character.

Das Design Center sieht sich als eine Alternative zum Pacific Design Center, um Möbeldesignern die Chance zu geben, ihre Produkte der Öffentlichkeit zu zeigen. Der bestehende Klinkerbau wurde mit leichten und durchsichtigen Elementen erneuert, die den Design-Inhalt präsentieren und gleichzeitig den Lagerhallencharakter erhalten sollen.

Le Design Center se veut alternative au Pacific Design Center, et fournit aux concepteurs de mobilier le public et l'audience dont ils ont besoin. Le bâtiment en brique originel a été valorisé à l'aide de matériaux légers et transparents, pour légitimer le contenu de sa conception tout en préservant son caractère premier : celui d'un entrepôt.

El Design Center se presenta como un alternativo del Pacific Design Center. Dando la oportunidad a los diseñadores de muebles de exponerse en este centro. El edificio existente de ladrillo se reforma con el uso de materiales transparentes para así establecer el contenido del diseño y al mismo tiempo preservando la apariencia del almacén.

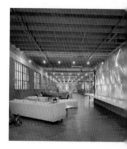

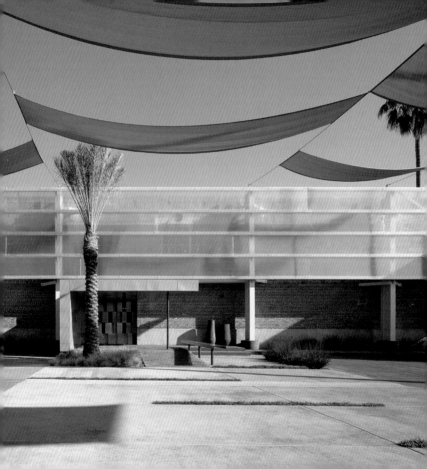

Index Architects / Designers

Index Structural Engineers

Index Districts

Photo Credits

Imprint

Copyright © 2004 teNeues Verlag GmbH & Co. KG, Kempen

Published by teNeues Publishing Group

teNeues Book Division
Kaistraße 18
40221 Düsseldorf, Germany
Phone: 0049-(0)211-99 45 97-0
Fax: 0049-(0)211-99 45 97-40
E-mail: books@teneues.de

teNeues Publishing Company
16 West 22nd Street
New York, N.Y. 10010, USA
Phone: 001-212-627-9090
Fax: 001-212-627-9511

teNeues Publishing UK Ltd.
P.O. Box 402
West Byfleet
KT14 7ZF, UK
Phone: 0044-1932-403 509
Fax: 0044-1932-403 514

Press department: arehn@teneues.de
Phone: 0049-(0)2152-916-202

teNeues France S.A.R.L.
4, rue de Valence
75005 Paris, France
Phone: 0033-1-55 76 62 05
Fax: 0033-1-55 76 64 19

www.teneues.com
ISBN 3-8238-4584-5

Bibliographic information published by Die Deutsche Bibliothek
The Deutsche Bibliothek lists this publication in the Deutsche Nationalbibliografie;
detailed bibliographic data is available in the Internet at http://dnb.ddb.de

Editorial project by fusion-publishing GmbH stuttgart los angeles
Editorial research & coordination by Sabina Marreiros,
Nicole Häusermann, Michelle Galindo
Edited and written in English and German by Karin Mahle
Concept by Martin Nicholas Kunz
Layout & pre-press: Thomas Hausberg
Imaging: Jan Hausberg
Maps: go4media. – Verlagsbüro, Stuttgart

www.fusion-publishing.com

Translation: ADE-Team, Stuttgart
French: Dominique Santoro
Spanish: Michelle Galindo

Special thanks to L.A. Inc www.laphototour.com, www.visitlosangeles.info for their expert adivse and W Los Angeles Westwood, Crescent, Raffles L'Ermitage, Mosaic Hotel, Crescent Hotel, Farmer's Daugther, Sunset Marquis Hotel & Villas, Elan Hotel, The Standard Downtown for their support.

Printed in Italy

While we strive for utmost precision in every detail, we cannot be held responsible for any inaccuracies neither for any subsequent loss or damage arising.

see detailed map on next pa

12

27

Bel Air

04

Hollywo

Beverly Hills

49 — 75

Pacific Palisades

52

2

14

39 46 47 48

05

50

18

10

405

15 16 17

Culver City

10

51

Venice

09

07

62

08

19 40

1

42

Santa Monica

61

69

76

06

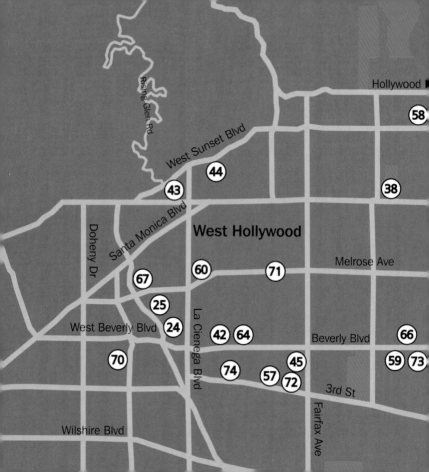

Franklin Ave

Vine St

Sunset Blvd

Hollywood

Santa Monica Blvd

Highland Ave

Rossmore Ave

Wilshire Country Club

and : guide

Size: 12.5 x 12.5 cm / 5 x 5 in. (CD-sized format)
192 pp., Flexicover
c. 200 color photographs and plans
Text in English, German, French, Spanish

Other titles in the
same series:

Amsterdam
ISBN: 3-8238-4583-7

New York
ISBN: 3-8238-4547-0

Barcelona
ISBN: 3-8238-4574-8

Paris
ISBN: 3-8238-4573-X

Berlin
ISBN: 3-8238-4548-9

Tokyo
ISBN: 3-8238-4569-1

London
ISBN: 3-8238-4572-1

To be published in the
same series:

Athens
Cape Town
Copenhagen
Hamburg
Hong Kong
Madrid
Miami
Milan

Moscow
Rome
San Francisco
Shanghai
Singapore
Stockholm
Sydney
Vienna

teNeues